MIXED-MEDIA MOSAICS

TECHNIQUES AND PROJECTS
USING POLYMER CLAY TILES, BEADS
AND OTHER EMBELLISHMENTS

LAURIE

MIKA

NORTH LIGHT BOOKS
CINCINNATI, OHIO

11 10 09 08 07 5 4 3 2 1

Distributed in Canada by Fraser Direct
100 Armstrong Avenue
Georgetown, ON, Canada L7G 5S4
Tel: (905) 877-4411

Distributed in the U.K. and
Europe by David & Charles
Brunel House, Newton Abbot, Devon, TQ12 4PU,
England
Tel: (+44) 1626 323200,
Fax: (+44) 1626 323319
E-mail: postmaster@davidandcharles.co.uk

Distributed in Australia by Capricorn Link
P.O. Box 704, S. Windsor, NSW 2756 Australia
Tel: (02) 4577-3555

 Mika, Laurie. Mixed-media mosaics : techniques and projects using polymer clay tiles, beads and other embellishments / Laurie Mika.
 p. cm.
 Includes bibliographical references and index.
 ISBN-13: 978-1-58180-983-1 (pbk. : alk. paper)
 ISBN-10: 1-58180-983-2 (pbk. : alk. paper)
 1. Mosaics--Technique. 2. Handicraft. I. Title.
TT910.M53 2007
738.5--dc22
 2007000094

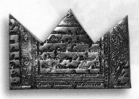

METRIC CONVERSION CHART

to convert	to	multiply by
Inches	Centimeters	2.54
Centimeters	Inches	0.4
Feet	Centimeters	30.5
Centimeters	Feet	0.03
Yards	Meters	0.9
Meters	Yards	1.1
Sq. Inches	Sq. Centimeters	6.45
Sq. Centimeters	Sq. Inches	0.16
Sq. Feet	Sq. Meters	0.09
Sq. Meters	Sq. Feet	10.8
Sq. Yards	Sq. Meters	0.8
Sq. Meters	Sq. Yards	1.2
Pounds	Kilograms	0.45
Kilograms	Pounds	2.2
Ounces	Grams	28.3
Grams	Ounces	0.035

EDITOR
Tonia Davenport

ART DIRECTOR AND DESIGNER
Amanda Dalton

PRODUCTION COORDINATOR
Greg Nock

PHOTOGRAPHERS
Christine Polomsky
Tim Grondin
Terrance Stewart

STYLIST
Louis Rub

DEDICATION

To my **FAMILY** , all of you, my parents, siblings, in-laws,
nieces, nephews, cousins, aunts and uncles, you know who you are
and that none of this matters if you don't have family to share it with!
In particular, my husband, **DAVID** , for always encouraging me, for
supporting me (literally!), for believing in me, for helping with all
of the important little things that keep my studio running and, above
all else, for loving me, always. To my children, **IAN** , **EMILE** ,
COLIN and **CORINNE** , thanks for being so easy to love and
for making my job as a mom almost effortless. How did I ever get so
lucky? You are the jewels that make up the mosaic that is my life.

ACKNOWLEDGMENTS

Kudos to **TONIA** Davenport (tile nipper extraordinaire) for her easygoing nature, her
unending patience and for making the entire experience of writing a book fun (at least for
me)! Thanks to **CHRISTINE** Polomsky for her enthusiasm and for her ability to make
every shot seem special. Many thanks to **AMANDA** Dalton for her creative input and
design ability to really capture the "look" I was hoping for. An amazing effort.
Special thanks to all of the behind-the-scenes people at **NORTH** **LIGHT**
who contributed to the magic that is this book. Many heartfelt thanks to the incredible
ARTISTS and friends along the way who have inspired me beyond measure.
Lastly, thanks to all of my **GAL PALS** , for always being there (not just at coffee).
You're the best!

Contents

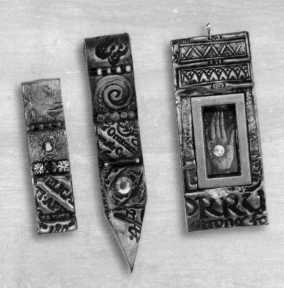

CREATIVE EVOLUTION

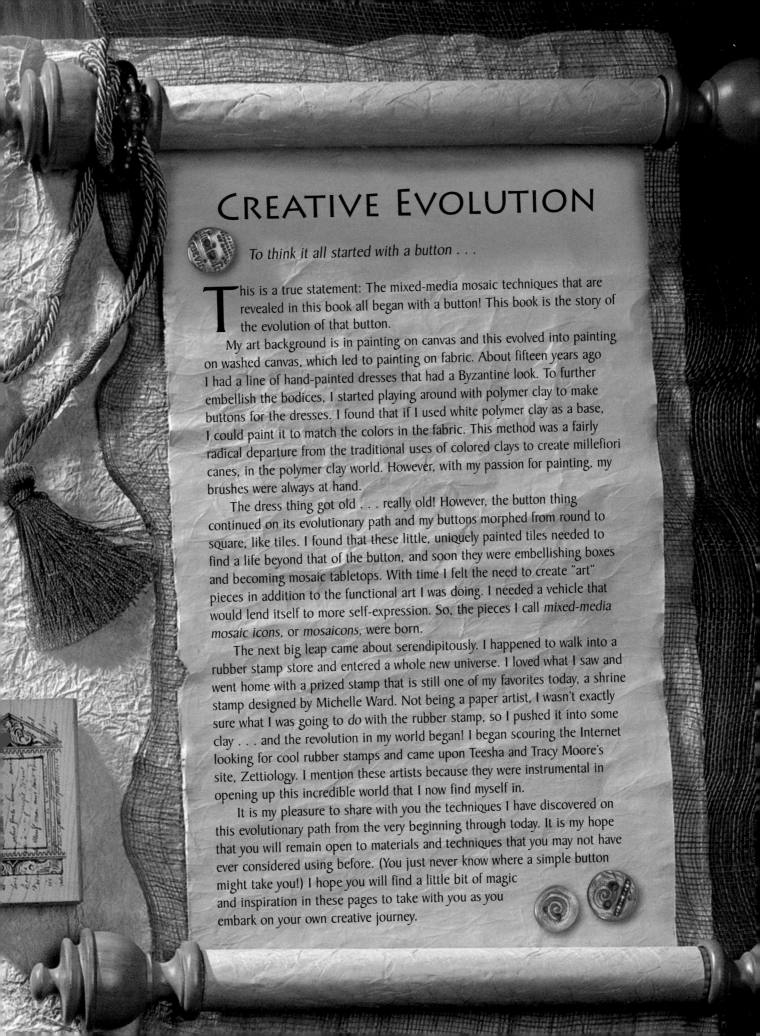

To think it all started with a button . . .

This is a true statement: The mixed-media mosaic techniques that are revealed in this book all began with a button! This book is the story of the evolution of that button.

My art background is in painting on canvas and this evolved into painting on washed canvas, which led to painting on fabric. About fifteen years ago I had a line of hand-painted dresses that had a Byzantine look. To further embellish the bodices, I started playing around with polymer clay to make buttons for the dresses. I found that if I used white polymer clay as a base, I could paint it to match the colors in the fabric. This method was a fairly radical departure from the traditional uses of colored clays to create millefiori canes, in the polymer clay world. However, with my passion for painting, my brushes were always at hand.

The dress thing got old . . . really old! However, the button thing continued on its evolutionary path and my buttons morphed from round to square, like tiles. I found that these little, uniquely painted tiles needed to find a life beyond that of the button, and soon they were embellishing boxes and becoming mosaic tabletops. With time I felt the need to create "art" pieces in addition to the functional art I was doing. I needed a vehicle that would lend itself to more self-expression. So, the pieces I call *mixed-media mosaic icons,* or *mosaicons,* were born.

The next big leap came about serendipitously. I happened to walk into a rubber stamp store and entered a whole new universe. I loved what I saw and went home with a prized stamp that is still one of my favorites today, a shrine stamp designed by Michelle Ward. Not being a paper artist, I wasn't exactly sure what I was going to *do* with the rubber stamp, so I pushed it into some clay . . . and the revolution in my world began! I began scouring the Internet looking for cool rubber stamps and came upon Teesha and Tracy Moore's site, Zettiology. I mention these artists because they were instrumental in opening up this incredible world that I now find myself in.

It is my pleasure to share with you the techniques I have discovered on this evolutionary path from the very beginning through today. It is my hope that you will remain open to materials and techniques that you may not have ever considered using before. (You just never know where a simple button might take you!) I hope you will find a little bit of magic and inspiration in these pages to take with you as you embark on your own creative journey.

SUPPLIES AND TOOLS
(A.K.A. THE RIGHT STUFF)

I'm not sure about you, but I am a supply junkie. There are so many cool supplies on the market that it is hard to control oneself. However, there are just a few essential tools and supplies to get you going on your way to making mosaic tiles. There are a few things I can't live without, my trusty rolling pin being one. When it comes to creating mosaics with polymer clay, you will find that certain supplies and tools may work better for you than for me; a lot of it is personal preference. There is no right or wrong way. The following is the "right stuff" that works for me.

MANUFACTURED TILE

Once you begin making your own handmade tile, you will realize the importance of commercially available tiles! They are ready to use and will help you fill space, especially on large pieces. They are also great to alter; see page 13 for some techniques. Manufactured tiles are available everywhere from home improvement stores to craft stores. I buy most of mine online, as there is a huge selection just a click away. Don't forget to check out eBay as a resource for finding unique tiles at great prices.

In the mosaic world, the technical word for tile is *tesserae*. The types of tesserae that I most often use are:

Vitreous glass—I tend to prefer iridescent colors.

Smalti—(I use mostly gold chips.) These are small rectangular pieces of opaque glass that come from Italy.

Gold-brushed ceramic micro-mosaics—
These are small squares that fill in small spaces.

Porcelain tile—This tile is great for stamping on.

POLYMER CLAY

You will find that polymer clay is one of the most versatile mediums to work with. I am continually searching for new ways to push it beyond its intended use. I primarily work with three types of polymer clay, each for a particular job.

Original Sculpey—I love that this clay doesn't need a lot of conditioning and it readily accepts paint. This is what I use for the white tiles you'll see me painting.

Premo!—I use Premo! for tiles that will be rubber stamped. While it is harder to condition than Scupley, its firmness makes it ideal for maintaining a stamped image.

Super Sculpey—Due to its strength and durability, this clay works great for making molds and things like buttons that are frequently handled. It can be primed with white paint, prior to painting, to cover up the fleshy color.

OTHER ESSENTIALS

Here are just a few other materials that you'll want to have on hand to create your own artful tiles.

Mika powders—Oops, I mean mica powders! I primarily use PearlEx.

Acrylic paint—I use it straight out of the tube, and I buy what's on sale.

Weldbond glue—This glue is a bit hard to find but worth it! Try Ace Hardware stores or online.

Concrete Patch—For heavy duty adhesion.

Diamond Glaze—For applying seed beads as grout.

Gold gel pens—To fill in the cracks on painted tiles.

Metallic leaf—An essential ingredient to grout sticks (page 27).

Sculpey Gloss Glaze or matte varnish—This protects all of your hard work.

Seed Beads—I use plenty of these as grout or embedded into clay.

Gel Medium—For all types of applications from acting as an adhesive in collage to making transfers on clay.

Scribbles—Dimensional paint in small bottles with a tip, for making tiny decorative dots.

Spray paint—I use this as a background basecoat.

Ceramic tile adhesive also called mastic—This adhesive gives a tooth for the tiles to stick to. You can also use it to create a texture on your spray-painted base.

TOOLS OF THE TRADE

Just as important as having the right supplies, having the right tools makes the job so much easier. (Though they're not as much fun to buy!) There are a few tools I can't live without. Again, I will make the disclaimer that what works for me might not work for you; so experiment and play and soon you will find your own "can't-live-without" tools.

Rolling pin—I love my grungy old wood rolling pin, but an acrylic rolling rod is fine or even a piece of PVC pipe works great too! Note: You may be wondering why I don't use a pasta machine to condition and roll out the clay. The answer is that I usually work with a slab of clay that is about 1/8"–1/4" (3mm–6mm) thick, and the pasta machine setting is just too thin.

Clay blades—I use sturdy, rigid blades for nice clean cuts.

Non-serrated knife—A good old kitchen knife can cut long strips of clay.

Scalpel—I use this for precise surgery on some of the tiles!

Needle tool—One of these works perfectly for embedding beads into clay.

Paintbrushes—A variety is good, but you'll especially want a fine detail brush.

Rag—Use a soft, T-shirt type without texture for the "lick and dab" method.

Roasting pans and binder clips—You'll want these for baking the tiles. (See page 17.)

Tile nippers—I like the wheel type best (especially when precisely cutting tiny pieces of glass tile) but any type will work fine for cutting small pieces of commercial tile.

Tin snips—These are great for cutting baked tiles and grout sticks.

Craft sticks—These sticks are used for numerous applications, including making channels for beads in clay.

TILE TECHNIQUES

Tile, tiles, tiles—where do I begin? As my editor, Tonia, told me, "better ingredients make a better pie." In this case, creating your own one-of-a-kind handmade tiles makes for better mosaics! In this chapter, I will share with you the techniques for making your own custom tiles out of a ball of clay. I will also give you a few time-saving secrets for altering manufactured or commercial tile. There are so many ways to create, embellish and alter tile, and you will find that these are the main "ingredients" in my mixed-media mosaics.

PREPARING YOUR SURFACE
Facing a blank slate can be extremely intimidating and getting started is sometimes the hardest part of the creative process. I have often found that it is the base of a project that inspires all that follows. There are certain shapes or materials that lend themselves to particular looks. Many times it is the search for just the right foundation that inspires a particular piece. I like to scour discount stores, flea markets and home furnishing shops to try to find unique items or objects to embellish my tiles. You will also discover that what is beneath the surface is just as important as what is seen. Having a secure "ground" is essential when creating mosaics, and I will share with you a few of my techniques for preparing your surface for the right foundation.

MATERIALS

mastic (tile adhesive)

board

stylus or paintbrush

gold spray paint

acrylic paint (optional)

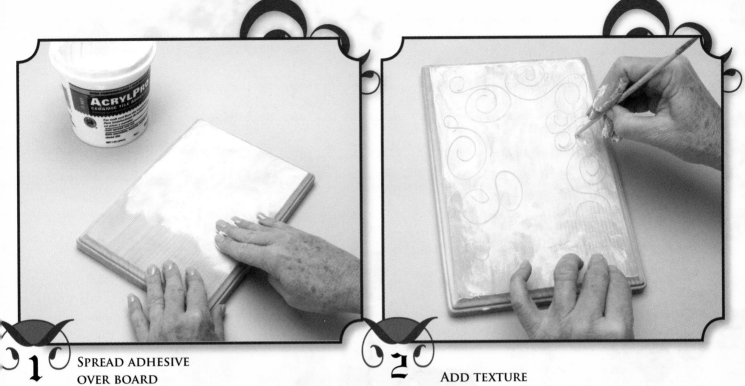

1 SPREAD ADHESIVE OVER BOARD

Apply a thin coat of tile adhesive to the surface you are going to be tiling. I prefer to add the adhesive with my hand. Here, I am using a wood plaque as my surface.

2 ADD TEXTURE

Paint will be applied when the adhesive is dry, so be sure you are happy with the texture of the adhesive surface. An alternative to a plain texture is to add script, or any line pattern, using a stylus or the end of a paintbrush.

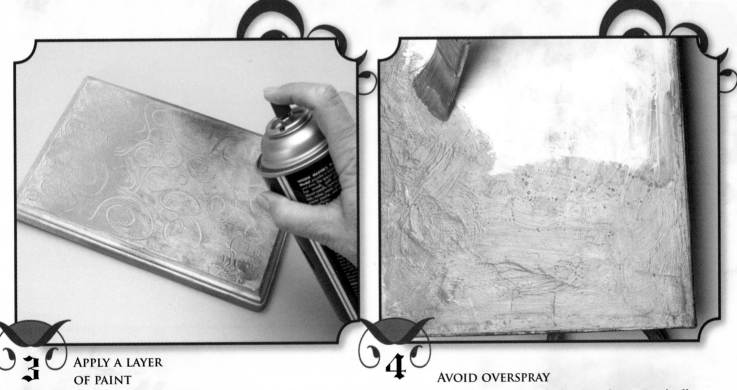

3 APPLY A LAYER OF PAINT

When the adhesive is dry, apply a coat of spray paint. Set the piece aside to dry.

4 AVOID OVERSPRAY

When you have a surface that you don't want to have to mask off, to avoid overspray, you may opt to paint it with a brush and acrylic paint instead.

WORKING WITH MANUFACTURED TILES

Once you've painted about a gazillion handmade tiles, you will come to appreciate the value of adding commercial glass tile to your artwork. I also like that it really helps to make the mosaic a true mixed-media piece. I buy clear glass utility jars to store my tile so that it is easy to see what I have when I sit down to actually put together a piece.

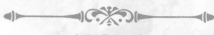

MATERIALS

glass tiles
sheet of porcelain tiles
wheel tile nippers
jewelry glue (Diamond Glaze)
mica powder (Pearl Ex)
metallic acrylic paint (FolkArt)
Distress inks (Ranger)
paper towels and rags
ink pad (StazOn)
rubber stamps
assorted acrylic paints
detail brush
pencil
ruler (optional)

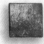

Cutting Glass Tiles

The first thing to remember when cutting glass tiles is that it is glass. Be careful. Wear goggles (I should practice what I preach!) and cut the tile into a box so that the fragments stay confined and you don't step on them later. (Ouch, I have done that!) That being said, it is fun to nip tile to fit the tiny spaces in your mosaics that are just crying out for a little something special. While it seems a bit tricky at first, you will quickly get the hang of it.

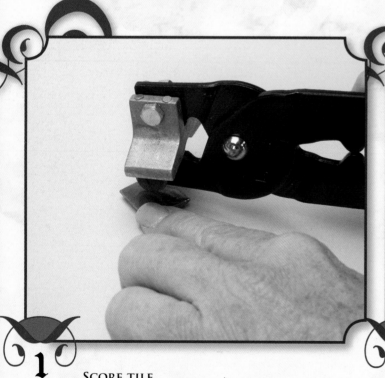

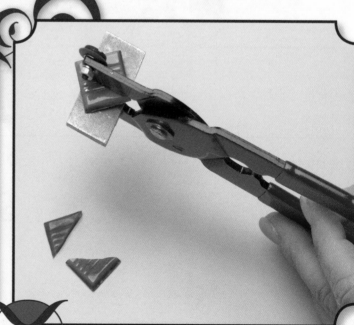

1 SCORE TILE

To cut tiles down, begin by scoring the tile where you want to cut it, using the glass wheel side of the nippers and if necessary, a ruler.

2 SNAP TILE

Place the scored tile into the nippers so that the score line is in the center and against the breaking plate. Squeeze the tool to snap the tile.

Altering Glass Tiles

I first started "altering" commercial tiles by rubber stamping on them. The porcelain tile works great for this. I loved how it looked, and this, of course, led to painting on the tile as well and experimenting with mica powders. Every extra step of embellishment pays off in the end. Remember, "better ingredients . . ."

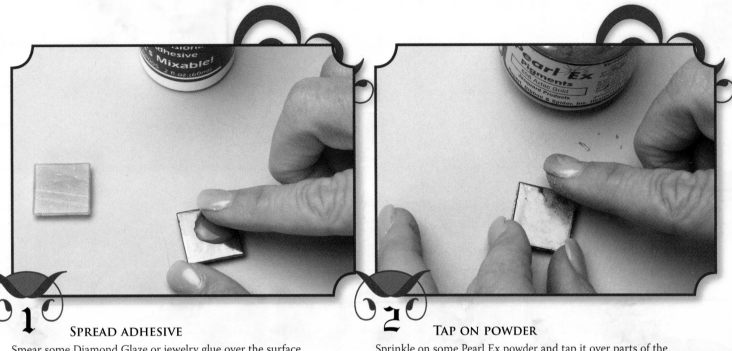

1 SPREAD ADHESIVE

Smear some Diamond Glaze or jewelry glue over the surface of the tile.

2 TAP ON POWDER

Sprinkle on some Pearl Ex powder and tap it over parts of the glued area, using your finger.

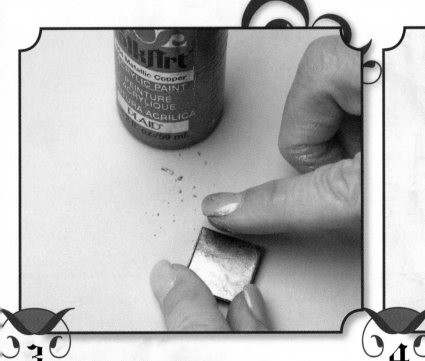

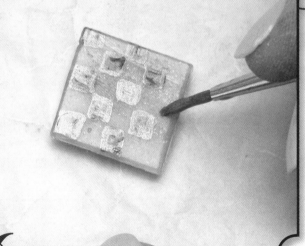

3 ADD SMUDGE OF PAINT

Smudge in a small amount of metallic paint with your finger to finish.

4 SIMPLY PAINT

Another thing that you can do with glass tiles is simply paint (a checkerboard, for example) on top of them with a detail brush, forgoing the mica powder.

Stamping Porcelain Tiles

I have found through experimentation that porcelain tiles have the best surface for rubber stamping. They have a bisque-like, non-gloss feel and they accept a stamped image like butter. (Okay, enough about the ingredients!) Another idea is to stamp an entire image onto a sheet of tiles and create a mosaic within a mosaic.

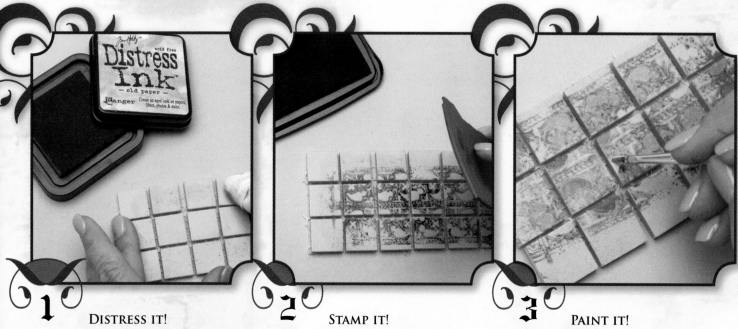

1 DISTRESS IT!

Start with a mesh square of porcelain tiles and, using a rag, swirl distress ink over some, but not all, of the surface of the tiles.

2 STAMP IT!

Using a StazOn ink pad, stamp an image over the entire surface of the tiles.

3 PAINT IT!

Let the ink dry, or use a heat gun to dry the stamped image. Then use a detail brush and thin acrylic paint to color in certain areas.

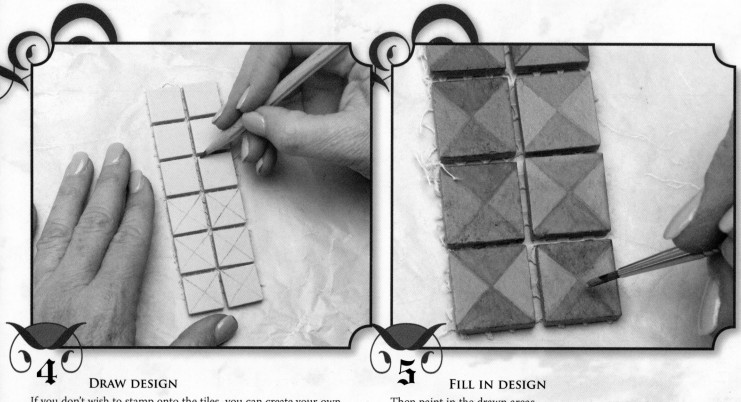

4 DRAW DESIGN

If you don't wish to stamp onto the tiles, you can create your own patterns or design with a pencil.

5 FILL IN DESIGN

Then paint in the drawn areas.

HAND-PAINTED TILES

Hand-painted tiles are really where it all began for me. I love painting, and I view each small unpainted white tile as a miniature canvas just waiting to be transformed. There is no replication—each tile is uniquely different (trust me, you can't duplicate a tile exactly, no matter how hard you try!). When creating mosaics, it makes all the difference in the world having your own color palette of tiles, colors that you would never find with store-bought tile. The result of adding hand-painted tiles to a mosaic provides added depth and beauty.

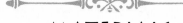

MATERIALS

original white Sculpey

wax paper

rolling pin

non-serrated knife

clay blade

quilt square rubber stamps

two roasting pans

binder clips

gel medium

color photocopy of an image

acrylic paint

paintbrush

rag or paper towels

detail brush

metallic gel pen

mica powders (Pearl Ex)

Rub 'n Buff

dimensional paint (Scribbles)

crystals or rhinestones

jewelry glue

ink pad (StazOn)

rubber stamps

Distress inks (Ranger)

Sculpey, Fimo glaze or matte varnish

 Making the Tiles

Polymer clay is fantastic; conditioning it is not! Many people use a pasta machine to condition their clay; I prefer the agony of doing it by hand. Once the clay is conditioned, you are on your way to rolling out a slab of clay and cutting individual tiles of all sizes and shapes.

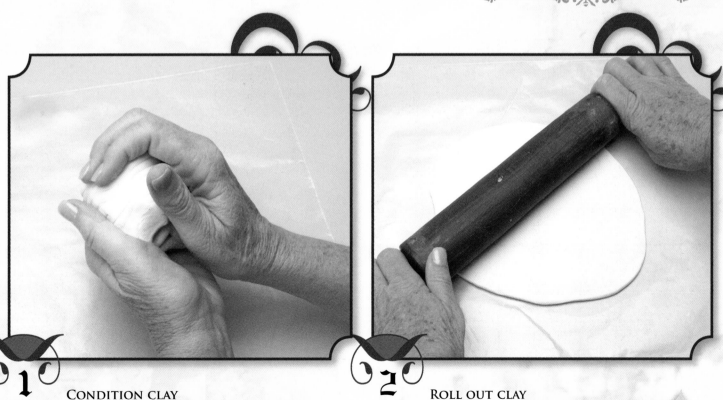

1 CONDITION CLAY

Take a hunk of white original Sculpey and knead (condition) it in your hands until it's nice and soft.

2 ROLL OUT CLAY

Spread wax paper out on your work surface, and, using a rolling pin, flatten the clay to a slab that is about ⅛" (3mm) thick.

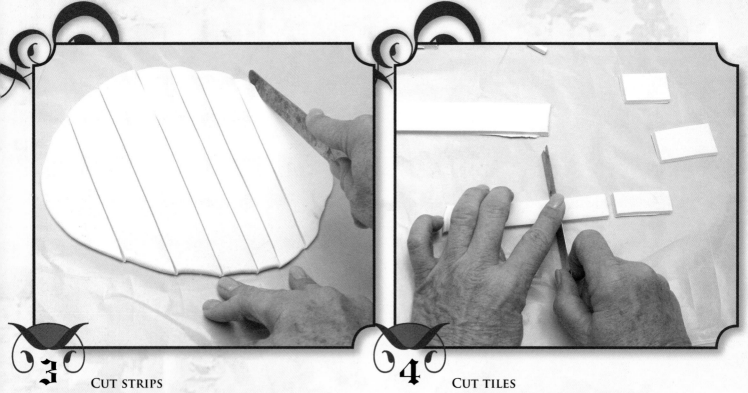

3 · CUT STRIPS

Use a non-serrated knife to make strips of varying widths.

4 · CUT TILES

With a clay blade, divide the strips of clay into a variety of individual tiles.

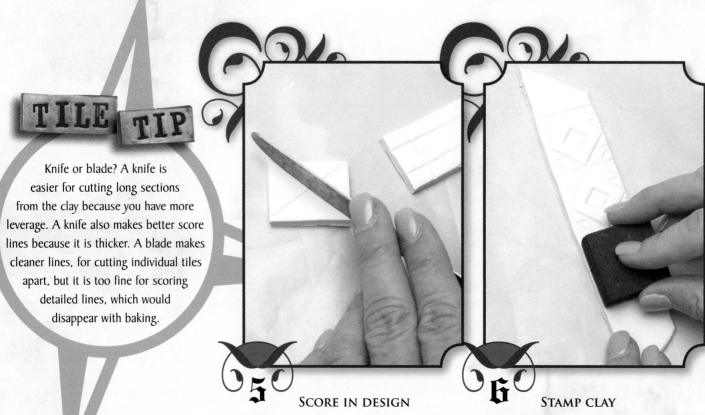

TILE TIP

Knife or blade? A knife is easier for cutting long sections from the clay because you have more leverage. A knife also makes better score lines because it is thicker. A blade makes cleaner lines, for cutting individual tiles apart, but it is too fine for scoring detailed lines, which would disappear with baking.

5 · SCORE IN DESIGN

Now, you can add scored detail lines, such as harlequin diamonds, stripes, or whatever you like, using the non-serrated knife.

6 · STAMP CLAY

You can stamp images into the clay at this stage if you like, but use simple stamps without fine detail because this type of clay is soft and a bit sticky, and small details can be lost. If you're going to do several stamped tiles, it's easy to make them in a row.

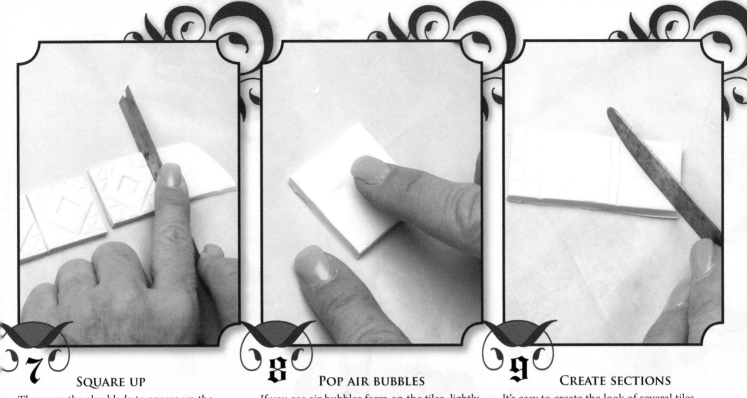

7 SQUARE UP

Then, use the clay blade to square up the individual tiles.

8 POP AIR BUBBLES

If you see air bubbles form on the tiles, lightly squash them with your finger.

9 CREATE SECTIONS

It's easy to create the look of several tiles together, using just a single tile. Section a longer tile out into a few separate areas, and then add scored designs to the individual sections.

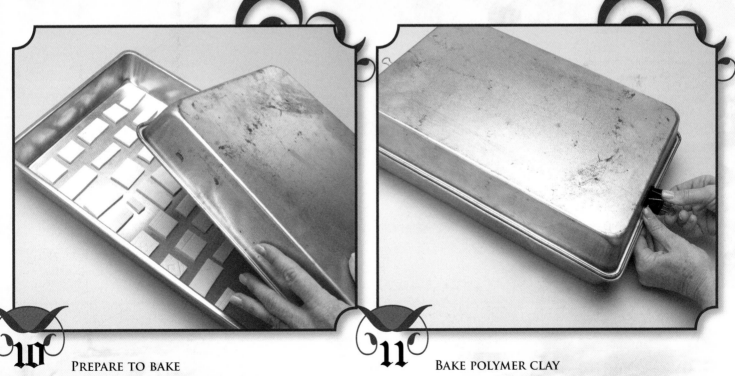

10 PREPARE TO BAKE

Fill a roasting pan with the tiles to prepare for baking. Make sure the tiles are not touching. Next, take a second pan of the same size and invert it over the filled pan.

11 BAKE POLYMER CLAY

Clamp the two pans together with binder clips. Pre-heat your regular oven and bake according to the instructions. (A toaster oven you designate for clay projects would also work.) Note: When the tiles are done baking, be sure to take the pan outside to vent. Set it down, remove one clip and knock the pan to the side, but be careful not to inhale the fumes as they escape! Leave the pan outside until cool. When cool, drop the pan from a few inches up to loosen any tiles that may have stuck to the bottom.

Making a Transfer

Another way to embellish a tile is by doing an image transfer. This is a technique that I have just begun to explore but I am already having lots of fun with this simple process. The polymer clay surface easily takes the gel medium and the image, creating very cool tiles to use in your mosaics.

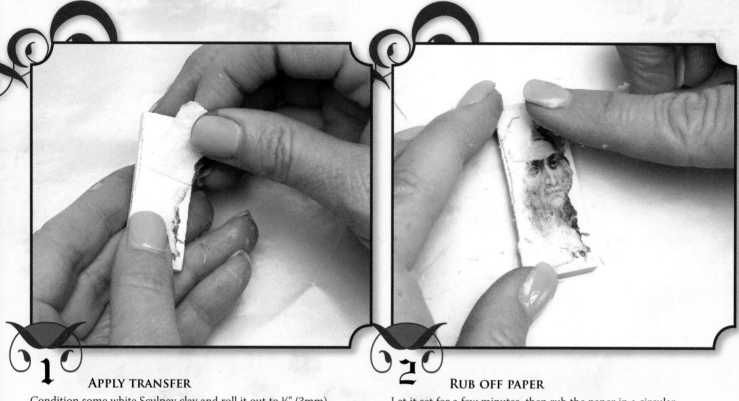

1 APPLY TRANSFER

Condition some white Sculpey clay and roll it out to ⅛" (3mm) thickness. Cut out a rectangle and bake as directed. Select an image and apply gel medium over the front of it. Place the image facedown on the tile and burnish well. Gently peel away the paper that comes off easily. You many not be able to see the image yet, and there may be a lot of paper that remains.

2 RUB OFF PAPER

Let it set for a few minutes, then rub the paper in a circular motion until the paper rubs off and you are left with the image.

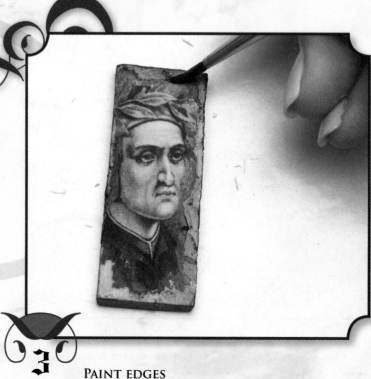

3 PAINT EDGES

Apply a wash of acrylic paint around the perimeter of the image, blending it into the edges so it looks seamless.

Painting Tiles

Now the fun begins! Mix your favorite colors to create groups of color-related tiles. It is good to have dozens of different tiles in various colors when you sit down to actually plan out your design. Variety is the spice of life, and when it comes to putting it all together you don't want to be limited by only having a few color groups of tiles. I like to have a variety of tiles so that I can juxtapose bold and pastel colors or primary and secondary colors. Remember, more is more!

Like a coloring book! The scored or stamped lines make it easy to paint multiple colors on the tile surface. Just think of it as filling in the lines.

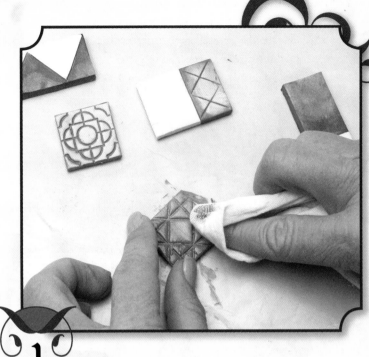

1 APPLY BASE COAT

To begin painting the tiles, it's easiest to do them in batches of related colors (for instance, all in combinations of purple, teal, periwinkle and magenta). Begin with a base coat of acrylic paint that will fill in all of the crevices of the scored lines. Brush paint onto either a section or an entire tile, then, with a rag or paper towel, dab some of the paint off. Add some of the first color to some portion of each of the tiles in the batch.

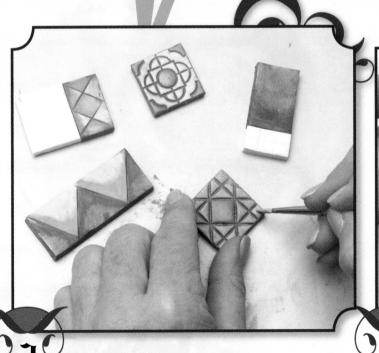

2 FILL IN AREAS

Decide on a second color, and add it to a section of each tile. Wipe (or dab) the excess paint off with a rag.

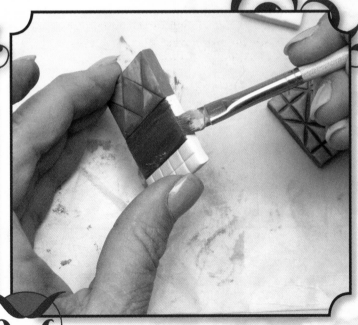

3 PAINT EDGES

Pick a third color and repeat painting and wiping off individual sections. Remember to carry the design over the sides of the tiles as well. (You never know which tiles might end up on the outside of a piece.)

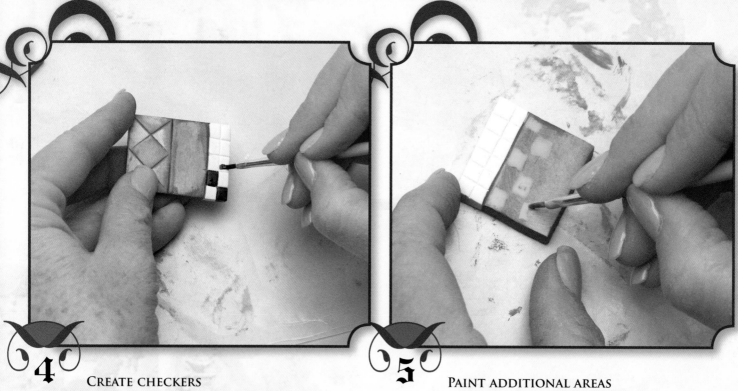

4 CREATE CHECKERS

I like to use a lot of black and white checks in my work. To create this look, don't bother painting areas of the tile white if your Sculpey is white to begin with! Simply add the black checks with a fine detail brush.

5 PAINT ADDITIONAL AREAS

For an area of a tile that doesn't have many score lines, you can fill it in with a contrasting color of paint, in whatever manner you choose. Here, I am creating my favorite checkerboard pattern, using paint that has been watered down to an inky consistency.

TILE TIP

Mix it up! Try creating new colors to add to your batch by mixing together the three or four basic colors that you are working with in your palette and also by adding a touch of white paint.

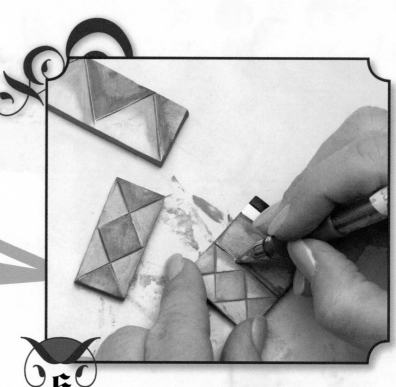

6 OUTLINE IN GOLD

Use a gold gel pen to fill in all of the scored lines. Simply drag the pen through the indentation. If you get ink where you don't want it, quickly rub it off.

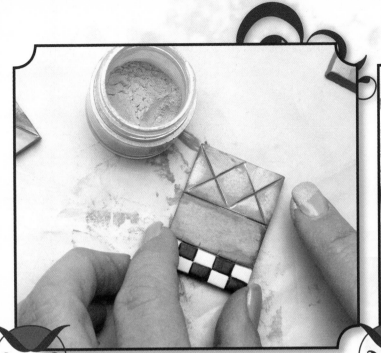

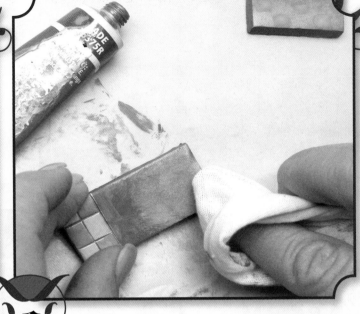

7 APPLY MICA POWDERS

Apply Pearl Ex powder to areas for a nice luster. Before applying the powder to the tile, dab it onto your work surface with your finger to get any clumps out.

8 GILD TILE EDGES

Rub 'n Buff can also be applied, but it isn't as forgiving as the powders, so apply lightly because once it is on, it is on! I like to add just a bit around the edges. Rub a small amount on with your fingers and wipe off the excess with a rag.

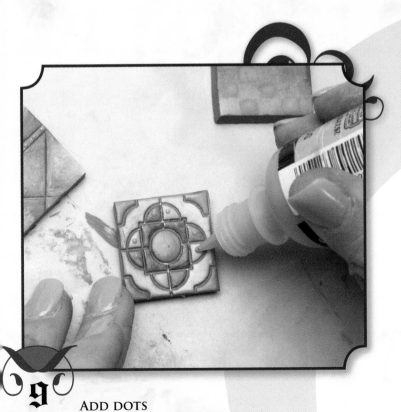

9 ADD DOTS

Make tiny dots using a Scribbles iridescent paint tube with a tip or paint with the end of a small paintbrush.

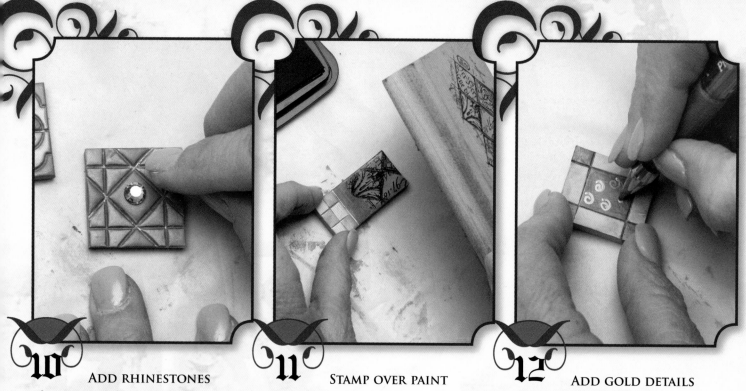

10 ADD RHINESTONES

After your painted tiles are dry, there are several additional ways you can continue to add interest to them by embellishing them in the ways shown here. Add rhinestones with just a tiny dot of jewelry glue.

11 STAMP OVER PAINT

Stamp images onto the tiles using StazOn. Remember, you will often only need to ink up a portion of the stamp.

12 ADD GOLD DETAILS

A gel pen can add great detail such as writing, outlining, or making shapes such as these swirls.

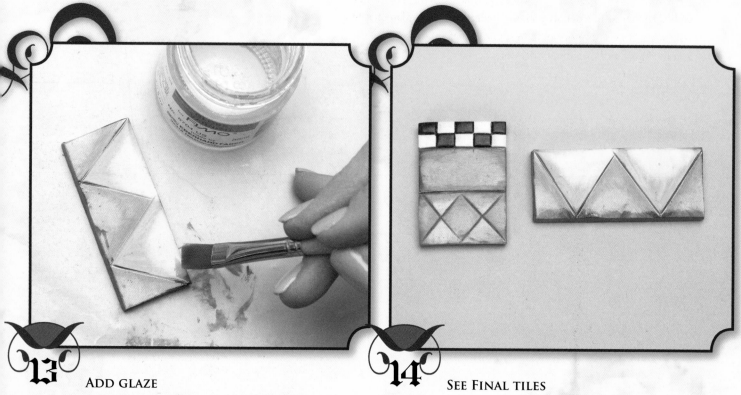

13 ADD GLAZE

Finally, it's very important to seal your finished painted tiles so all of your hard work isn't scratched or rubbed off. You can use either a matte or glossy varnish depending on the look you'd like to achieve.

14 SEE FINAL TILES

Here are two painted tiles with varnish that has dried—one matte, the other glossy.

STAMPED TILES

Stamping on polymer clay is still one of the greatest thrills for me. (OK, that may be a bit of an exaggeration.) The best part is using mica powders to reveal the design; I just never get tired of that. I refer to this process in my classes as the "magic show." It is analogous to temple rubbings (only you're in your studio, not in Bangkok!). If you have never stamped on polymer clay, you are in for a real treat. Oh, the possibilities!

MATERIALS

polymer clay in the color of
your choice (Premo!)

rolling pin

wax paper

assorted rubber stamps

clay blade

mica powders (Pearl Ex)

charms or milagros

scalpel

metallic leaf

stir stick (or thin craft stick)

ruler (or craft stick)

needle tool or toothpicks

seed beads

square beads

pencil with eraser

crystals

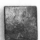 **Basic Stamping**

There are a few things to be mindful of when stamping into polymer clay. First, the clay should be just the right consistency—too soft and your stamp sticks in it, too firm and your image doesn't show up. Next, it is always important to use stamps that are made from deeply etched rubber, as fine details get lost. Finally, if you ever plan on selling your work, it's very important to use stamps that are from "angel companies" that allow you to freely use the images as long as you do not mechanically reproduce the image.

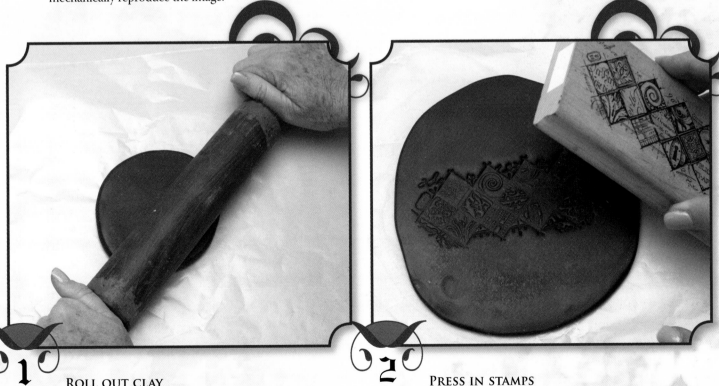

1 ROLL OUT CLAY

Condition a couple of pieces of Premo! clay. Roll out the clay on a piece of wax paper to a thickness of about ⅛" (3mm).

2 PRESS IN STAMPS

With even and firm pressure, stamp into the clay, pulling off one edge at a time to see if you have a good impression.

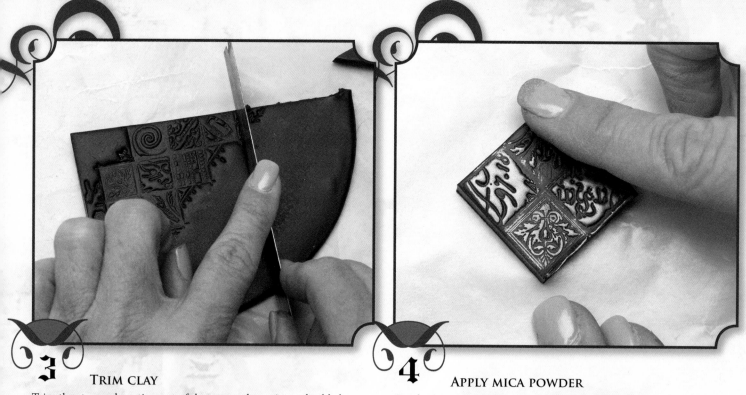

3 TRIM CLAY

Trim the stamped portion out of the excess clay, using a clay blade.

4 APPLY MICA POWDER

Cut the image down into several smaller pieces that will then be the tiles. With a small amount on your finger, rub on Pearl Ex powder, and see the magic unfold as the image is revealed!

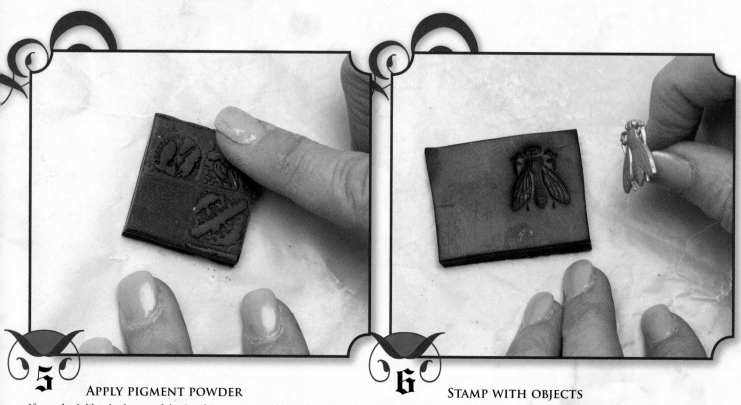

5 APPLY PIGMENT POWDER

If you don't like the luster of the Pearl Ex, you can add a subtle amount of color with dry pigment.

6 STAMP WITH OBJECTS

Found objects such as jewelry or small toys can also be used to stamp into the clay.

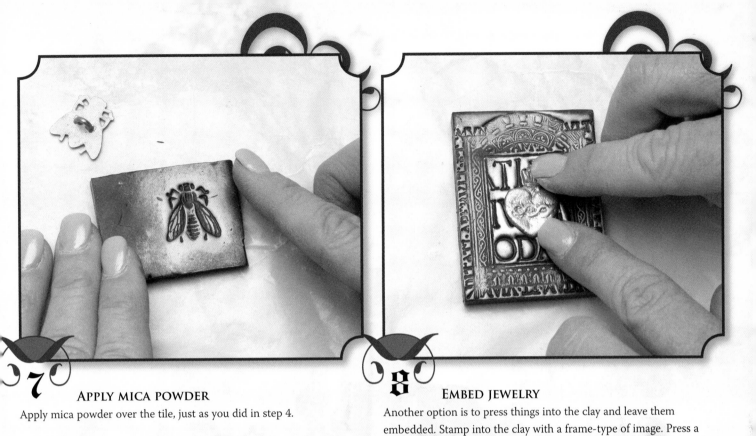

7 APPLY MICA POWDER

Apply mica powder over the tile, just as you did in step 4.

8 EMBED JEWELRY

Another option is to press things into the clay and leave them embedded. Stamp into the clay with a frame-type of image. Press a charm, button or small piece of jewelry into the clay. Bake as directed.

Raised and Recessed Shapes from Stamping

Once you have the basic stamping concept down, it is time to explore pushing *things* into clay that can create both raised and recessed shapes in the clay. I have a wooden heart stamp that, when pushed hard enough, creates a cool three-dimensional raised area. Conversely, you can use flat wood cutouts to make recessed areas in the clay that can then be further embellished.

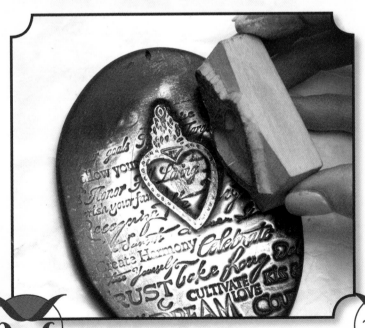

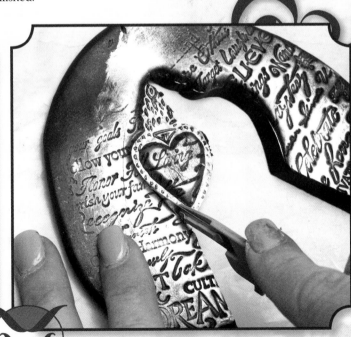

1 CREATE RAISED AREA

Condition and roll out some Premo! clay and stamp into it with a large textured background stamp. Then, apply mica powder to a heart or frame stamp that has the center cut out and firmly press into the previously stamped clay to create a raised area.

2 CUT OUT SHAPE

If you wish to use the heart on its own, cut out the shape with a scalpel, or you could cut out a square shape around the heart to have a square tile.

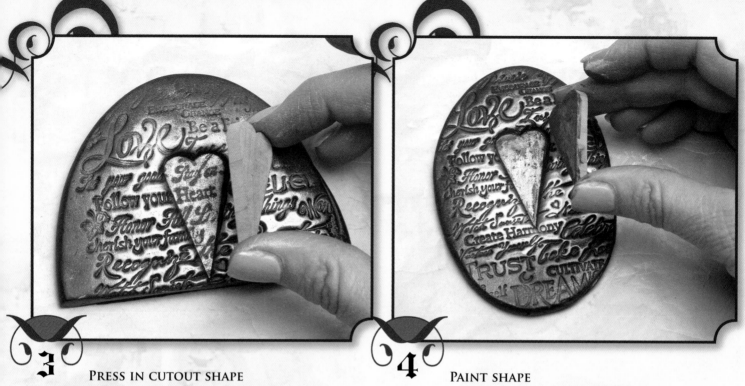

3 PRESS IN CUTOUT SHAPE

An easy way to get a recessed shape in a tile is to press a wood cutout into a rolled-out piece of clay that has been first stamped with a background stamp and has been rubbed over with mica powder.

4 PAINT SHAPE

To go a step further, apply paint to the cutout first.

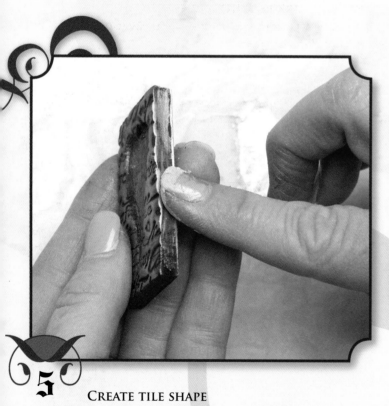

5 CREATE TILE SHAPE

Trim the clay to a rectangular tile shape, and apply additional mica powder to the sides.

Forming Metallic-Leaf Grout Sticks

So, just what *are* grout sticks anyway? *Grout sticks* is the name I came up with for the thin gold-leafed strips of clay that function as a visual sort of grout in my mosaics. I wanted to create the look of a gold bezel around the painted tiles and also to fill in the narrow gaps between tiles where little else will fit. These super-thin strips work great because they can be nipped to fit into all the odd spaces and can be used as an alternative to seed beads. Hey, anything to not have to deal with the mess of real grout!

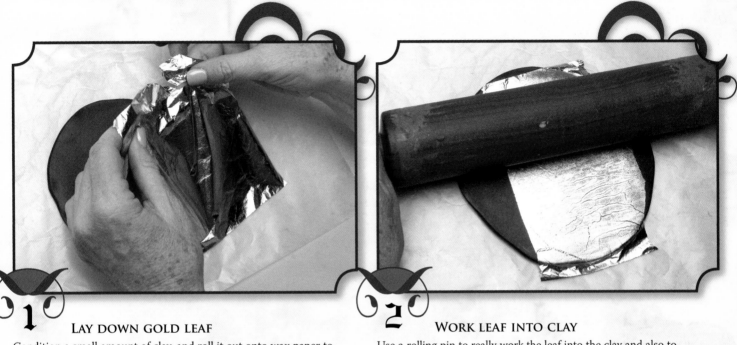

1 LAY DOWN GOLD LEAF

Condition a small amount of clay, and roll it out onto wax paper to ⅛" (3mm). Take one piece of gold (or silver) leaf and set it on the clay.

2 WORK LEAF INTO CLAY

Use a rolling pin to really work the leaf into the clay and also to give it a cracked appearance.

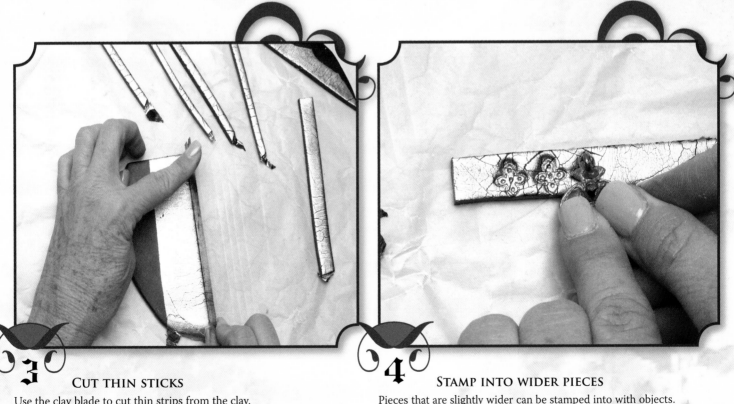

3 CUT THIN STICKS

Use the clay blade to cut thin strips from the clay.

4 STAMP INTO WIDER PIECES

Pieces that are slightly wider can be stamped into with objects. Bake as directed. See page 74 for a grout stick used in action.

27

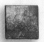

Stamping With Metallic Leaf

Metallic leaf, which comes in a variety of colors (gold is my favorite), is a great material to achieve that medieval look that I adore. Often it seems a bit bright, so using paint or ink to tone it down is something you might want to try. Once the leaf hits the surface of your clay slab, it sticks just as if the clay was glue. Be careful because once it is down, it is very hard to readjust—trust me!

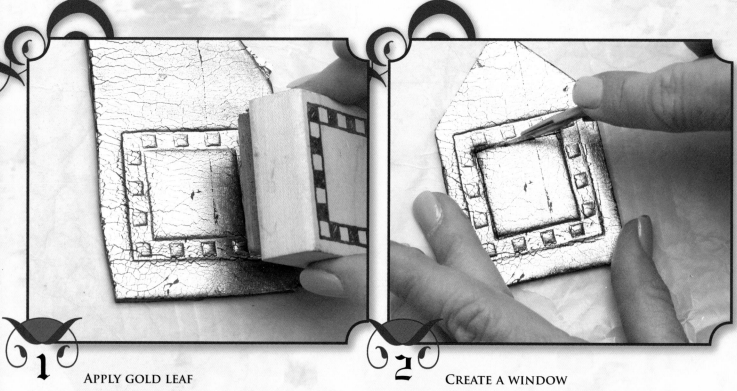

1 APPLY GOLD LEAF

Condition a small amount of clay, and roll it out onto wax paper to ⅛" (3mm). Take one piece of gold (or silver) leaf, set in on the clay and roll with a rolling pin to crack the leaf. Stamp into the leaf and clay with a rubber stamp.

2 CREATE A WINDOW

Trim the stamped image down using a clay blade, and then use a craft knife or scalpel to cut the window out of the center.

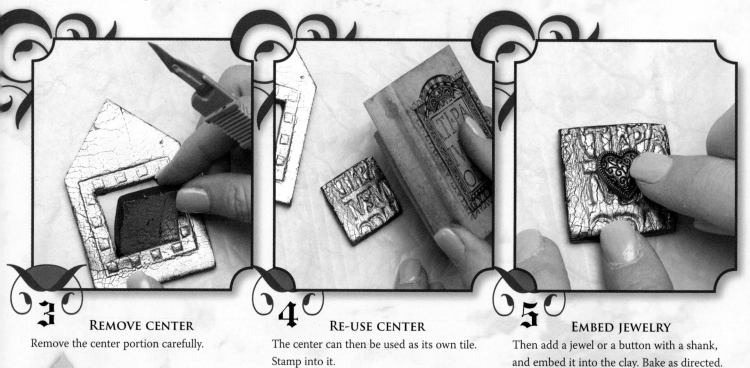

3 REMOVE CENTER

Remove the center portion carefully.

4 RE-USE CENTER

The center can then be used as its own tile. Stamp into it.

5 EMBED JEWELRY

Then add a jewel or a button with a shank, and embed it into the clay. Bake as directed.

Creating Jeweled Tiles

Beading into clay is a relatively new technique that I have been exploring, and I am addicted! I began experimenting by randomly pushing a few beads into a stamped image in clay to give it a bit of a sparkle. When I realized that I could create a channel (or bezel) with a row of beads—well, let's just say I was more than excited! My old needle tool, which is all gunked up, works great for picking up the individual seed beads and placing them into the clay. I have tried new needle tools and they didn't work; the beads just fell off. There is a low-tech solution—the mighty toothpick works just fine! Give it a whirl.

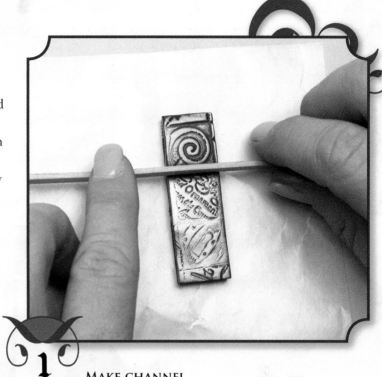

1 MAKE CHANNEL

Stamp some clay and cut out a small section in the shape of a long rectangle. Add mica powders, as desired. Use a stir stick to create a channel, and section off a portion of the tile.

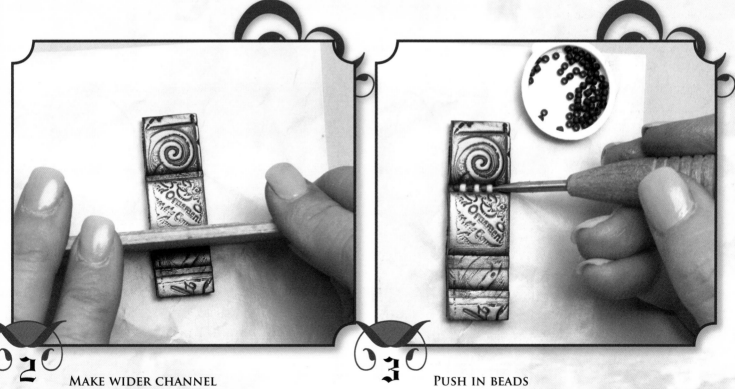

2 MAKE WIDER CHANNEL

Create a second channel with the stir stick. Then, use a ruler or wider stick (such as a craft stick) to create a third channel.

3 PUSH IN BEADS

Using a needle tool or a toothpick, pick up the beads and place them in the channel. I like to alternate colors. You can also try dipping your needle tool in water to help pick up the beads.

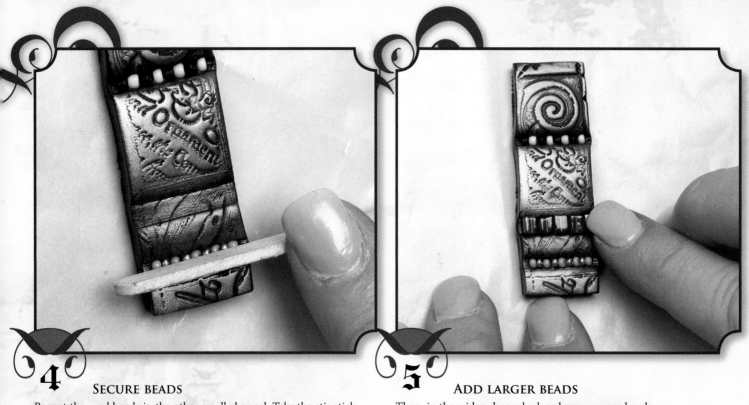

4 SECURE BEADS

Repeat the seed beads in the other small channel. Take the stir stick and gently press the entire row into the clay.

5 ADD LARGER BEADS

Then, in the wider channel, place larger, square beads.

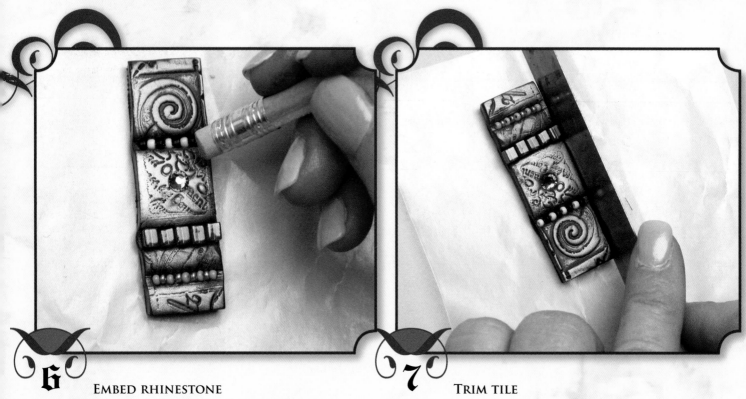

6 EMBED RHINESTONE

Press the square beads in with the ruler. Add a crystal or rhinestone in the middle section and press it in with a pencil's eraser.

7 TRIM TILE

Trim the edges a final time, using a clay blade. This is necessary because all of the pushing spreads the shape out a bit. Bake as directed.

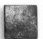

Combining Stamping Techniques

"More is more"—that's my motto, and I'm sticking to it! With all of the basic stamping concepts under your belt, you are ready to venture into combining various techniques. Stamping, painting, embedding and embossing—oh my! And all of this on just one little tile.

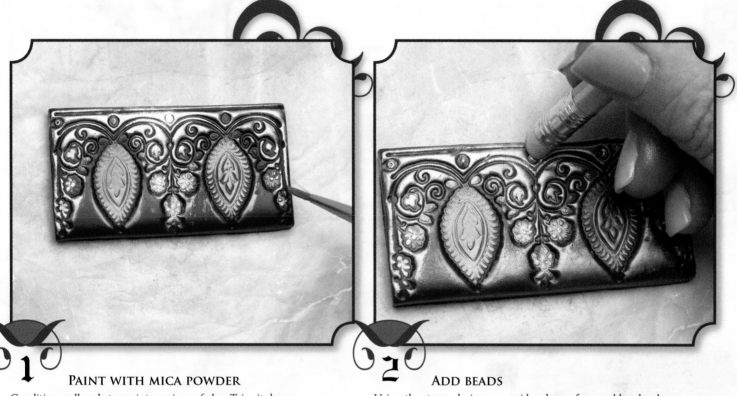

1 PAINT WITH MICA POWDER

Condition, roll and stamp into a piece of clay. Trim it down. Combine a small amount of gold mica powder and blue mica powder to create a third color (green). Mix a purple and a blue, and then spread some of that in the center. Spread the green powder around the edges. Then, use a paintbrush to spread some powder into areas that are hard to work into.

2 ADD BEADS

Using the stamp design as a guide, place a few seed beads where you want them. Then, use the eraser of a pencil to gently push the beads flush with the clay.

Eye shadow is just as effective as mica powders when adding luster to clay. (But I wouldn't recommend wearing Pearl Ex powders as eye shadow!)

CREATING MORE COMPLEX TILES

I love the ability to literally "push" the clay. Polymer clay is not only an extremely forgiving and versatile medium, but it is also very durable, allowing for all types of experimentation. Push it to the limit. Play with pushing paper, fabric and metal into it. If you don't like what you've created, just roll the clay into a ball and start over. How forgiving is that?

MATERIALS

polymer clay in the color of
your choice (Premo!)

rolling pin

wax paper

mica powders (Pearl Ex)

assorted rubber stamps,
including those with doors or
windows to act as a frame

paper or photo image

small scissors

jewelry glue

pencil with eraser

metal frame

clay blade

scalpel

letter stamps

decorative brads

tacks

stir stick (or thin craft stick)

needle tool or toothpicks

seed beads

crystals or rhinestones

acrylic paints

detail brush

metallic leaf

Super Sculpey

Creating Windows and Niches

There is something about making a little niche or window in clay that is very appealing to me, especially when you can place just a portion of a mysterious face peering out from behind the frame, as though the person just happened to walk by. Think of all the possibilities for placing photos of people you know behind these doors and windows.

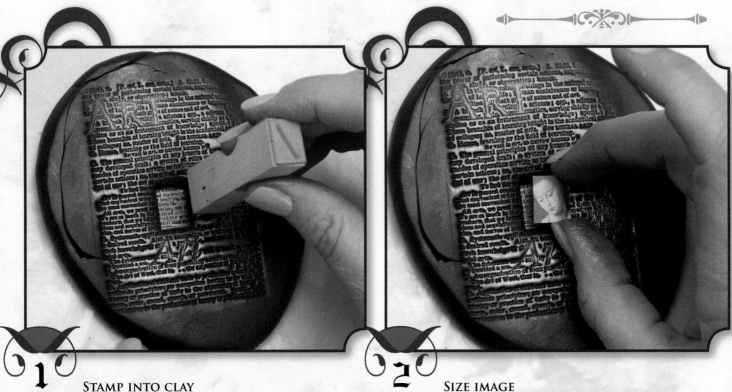

1 STAMP INTO CLAY

Condition and roll out a portion of clay to about a ⅜" (10mm) thickness. Apply some mica powder over the image. With the end of a small stamp, press firmly into the clay to create a window for your image.

2 SIZE IMAGE

Using the end of the same small stamp as a guide, trim the portion of the paper image that you wish to use. Use jewelry glue to glue the paper into the clay window.

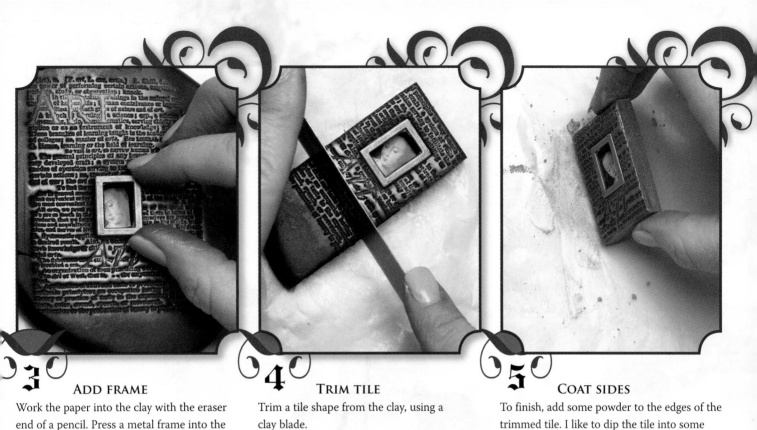

3 ADD FRAME

Work the paper into the clay with the eraser end of a pencil. Press a metal frame into the clay, over the image.

4 TRIM TILE

Trim a tile shape from the clay, using a clay blade.

5 COAT SIDES

To finish, add some powder to the edges of the trimmed tile. I like to dip the tile into some powder, then work it in with my finger.

Crowning Element

Somewhere along the way I got hooked on making crown frames. Again, I like the window that is used to create a focal point in a mosaic. I also love the royal look that it lends to a piece. When working with larger elements like this, I usually condition at least three packages of clay, which are blended together to make a large ball of clay. Any size of stamp will do for the frame portion, as I just draw the crown element on after I have stamped the clay.

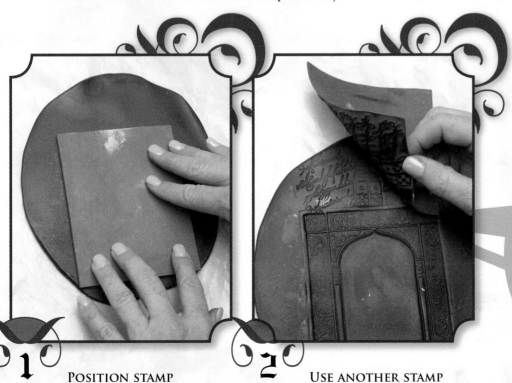

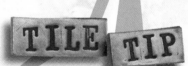

Remember to change your wax paper often so that powders and beads don't contaminate your clay.

1 POSITION STAMP

Condition and roll out your clay to ⅛" (3mm). Position a large frame stamp low enough on the piece of clay so that you will have room to draw in the crown at the top.

2 USE ANOTHER STAMP

For added texture, stamp with a second stamp on the area that will become the crown.

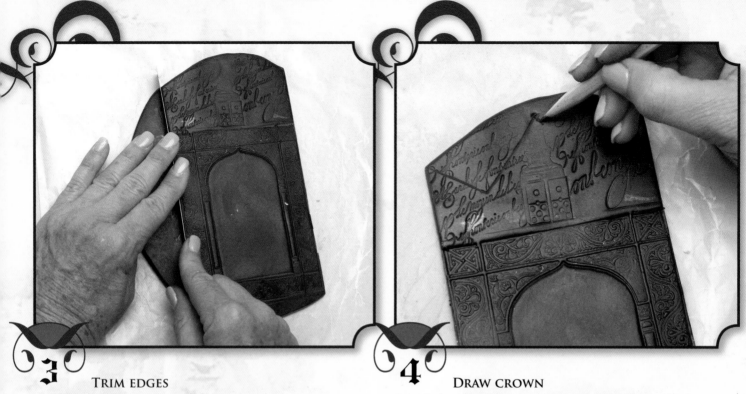

3 TRIM EDGES

Use a clay blade to cut the sides, extending beyond the frame portion all the way to the top.

4 DRAW CROWN

Trim the bottom of the frame with the blade as well. Locate the top center of the piece and make an indentation with a pencil. Then, lightly draw the crown spires in with the pencil.

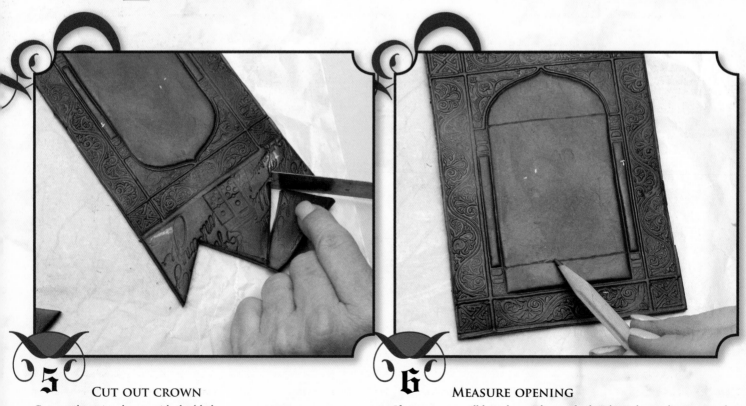

5 CUT OUT CROWN

Cut out the spire shapes with the blade.

6 MEASURE OPENING

If your crown will later be used on a shadow box, draw a line across the round part at the top, and do not remove the portion above that line.

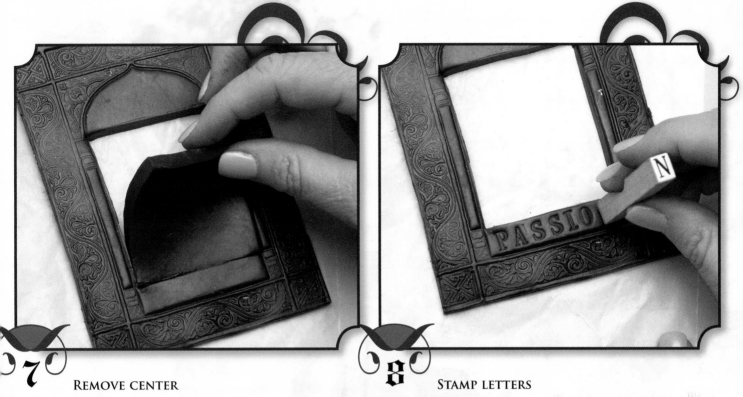

7 REMOVE CENTER
Use a scalpel to remove the window portion.

8 STAMP LETTERS
Use letter stamps to create a word at the bottom of the window.

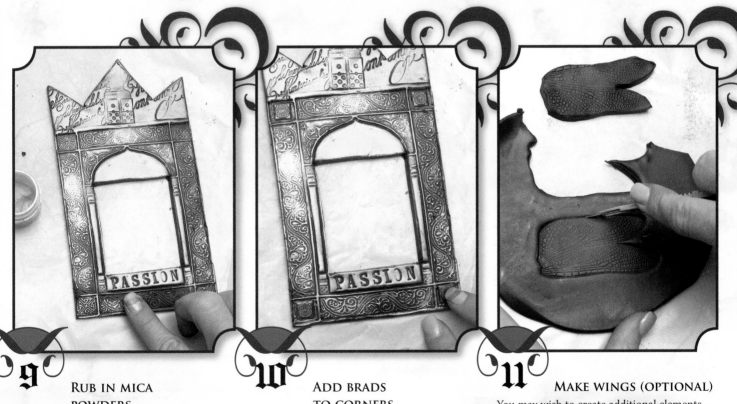

9 RUB IN MICA POWDERS
Using your finger, dab gold mica powder over the entire surface of the crown piece. For added depth, it's fun to add a second color of powder over the top of the gold. Here, I've used turquoise.

10 ADD BRADS TO CORNERS
Finally, add decorative brads in the corners. You may need to snip off the excess length of the brad shaft if it is longer than the thickness of the clay. Note: When you bake the piece, or any large element, make sure it is not askew in the pan or it will bake out of shape.

11 MAKE WINGS (OPTIONAL)
You may wish to create additional elements that go with the crown out of the same clay, while you have it handy. Here, I've created two wings, which will later be glued onto the sides of the crown frame.

Building a House

In addition to the crown shape, I also love houses, often using these houses as frames. I first began using the Zettiology neighborhood stamps years ago to create that shape in clay. Now, I will often use a background stamp for texture and then cut the entire slab into the shape of a house. Of course, this is the perfect shape to showcase my beloved windows. There are all types of architectural elements that can be added to literally build a house, piece by piece and layer by layer.

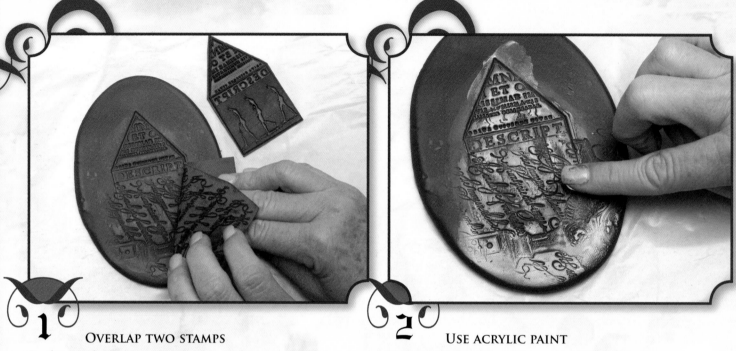

1 OVERLAP TWO STAMPS

Condition and roll out some brown Premo! clay to about ⅜" (10mm). Experiment with overlapping two different stamps.

2 USE ACRYLIC PAINT

Play around with adding different colors of acrylic paint on top of the stamped area. Use a combination of metallic paint and nonmetallic colors. (I use my fingers as a paintbrush.)

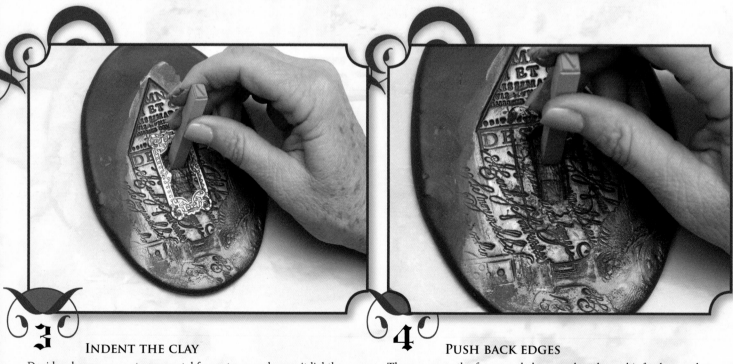

3 INDENT THE CLAY

Decide where you want your metal frame to go and press it lightly into the clay. For objects such as this frame that are irregular in shape, keep the frame on the clay and use it as a guide to create a series of indentations with a small stamp or other object.

4 PUSH BACK EDGES

Then, remove the frame and clean up the edges a bit further so that the opening will extend just slightly under the opening of the frame.

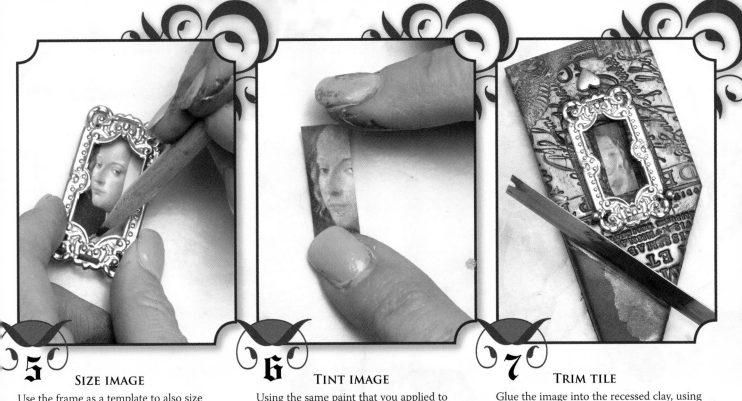

5 SIZE IMAGE

Use the frame as a template to also size your image.

6 TINT IMAGE

Using the same paint that you applied to the stamped clay, add a bit of color over the image as well.

7 TRIM TILE

Glue the image into the recessed clay, using jewelry glue. Use a clay blade to trim out the house shape from the clay.

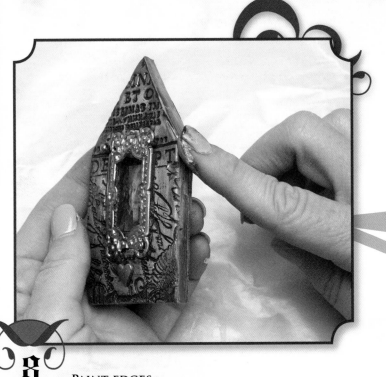

8 PAINT EDGES

Apply more paint to the sides of the trimmed clay. Bake as directed.

TILE TIP

As you are working with a piece of clay (stamping into it, trimming it, adding powders to it), it's important to periodically lift the clay piece off of the wax paper and set it down again, or else it can really get stuck to the paper and may tear when you lift it up.

Layering Elements

If one polymer clay frame is good, then two must be better! It is fun to experiment with layering clay frames to create a more three-dimensional look. It is natural for unbaked polymer clay to stick to another piece of unbaked clay, without using an adhesive. If you really want to secure two pieces; either you can nail them together with tacks, a look I really like, or you can use Translucent Liquid Sculpey (TLS) before baking. TLS can also be used to glue unbaked and baked pieces together. I really like the ability to actually build with separate polymer clay elements, and I'm always experimenting with even more layered mosaics.

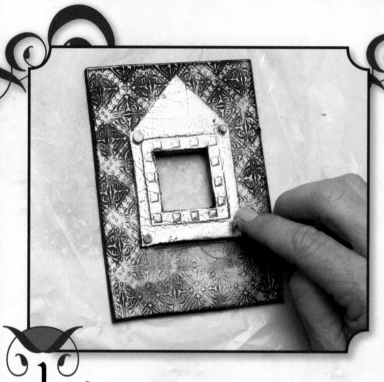

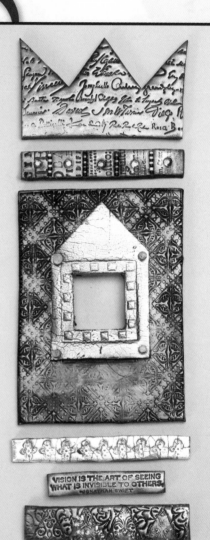

1 LAYER TWO OR MORE SHAPES

Condition and roll out your clay to ⅛" (3mm). Press a large frame stamp into the clay. Trim the frame down, using a clay blade. Apply mica powders to the surface of the frame. Create a smaller frame piece that is covered in metallic leaf (see page 27). Set the small frame over the larger one, and mark the corners of the small window onto the large piece. Trim the larger window out, making the opening slightly larger than the markings. Gently press the small frame over the large one, centering it in place. Press tacks through both pieces to secure. Bake as directed.

2 CREATE SEPARATE PARTS

Additional pieces can be created to combine later, to form an even larger piece. Here, I've made a crown that is separate from the frame and can be mounted above it. Also, grout sticks can be used as elements, as can text tiles.

Making Relief Molds

Having recently taken a semester of ceramics with a fabulous instructor and artist named Lana Wilson, I adapted this ceramic clay technique to use with polymer clay. Basically, you can make a mold of just about anything. This works especially well for making doll parts. Super Sculpey is great clay to use for this application because of its strength. After it's baked, it will withstand the repeated force of pushing clay into it. Now all you have to do is to start scouring the house for objects that can be used to make great molds.

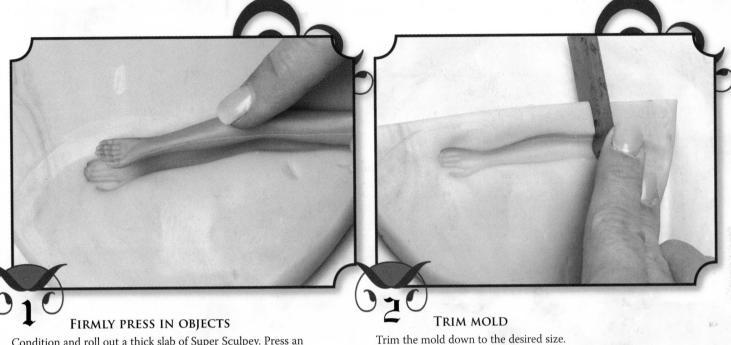

1 FIRMLY PRESS IN OBJECTS

Condition and roll out a thick slab of Super Sculpey. Press an object, such as a doll arm, into the clay, and remove.

2 TRIM MOLD

Trim the mold down to the desired size.

3 USE MOLD TO STAMP

Bake as directed. Condition a piece of Premo! and roll out to ⅛" (3mm) thickness. With the mold face up, press the rolled out clay into the mold. Invert and remove the clay from the mold.

4 FINISH WITH MICA POWDERS

Trim the relief down to the desired tile size, and add mica powder to finish. Bake as directed.

Bringing Meaning
Into Your Work

Creating mixed-media mosaics using your own handmade tiles gives you the advantage of making pieces that have lasting significance and meaning. I truly found this out when I began working on the icon "Tolerance." It was very cathartic to begin making tiles and collecting found objects to be used in a piece that symbolized my search for hope and understanding after September 11th.

Being able to personalize tiles and add text to your work takes it to another level. While I often use text just for the sake of adding texture to a piece, more often than not the small phrases and quotes are intentional guides to take the viewer inside my thoughts. I do believe that if you know my work, you will know me. My art is just the outward extension of myself—the interior self made visible. One need not use text to convey meaning; certainly most great art simply relies on the image, the process, the surface. However, the ability to combine both imagery and text, your own personal vocabulary, is a tool that allows for a great deal of self-expression.

How does this personal iconography or "vocabulary" evolve? I have often tried to analyze inspiration, trying to find the source of that unseen magic that happens when one allows for the serendipitous dabbling of the unconscious mind—that is, the creative force that speaks to us from within when our minds are free from extraneous thoughts. I think we can all agree that when our minds are preoccupied with the minutiae of everyday life, there is no room in our thoughts for much of anything else except attending to these details. At least, that is what holds true for me. It is when I am in that "creative zone" that all the ideas spill forth. Unfortunately, this usually happens in the middle of the night!

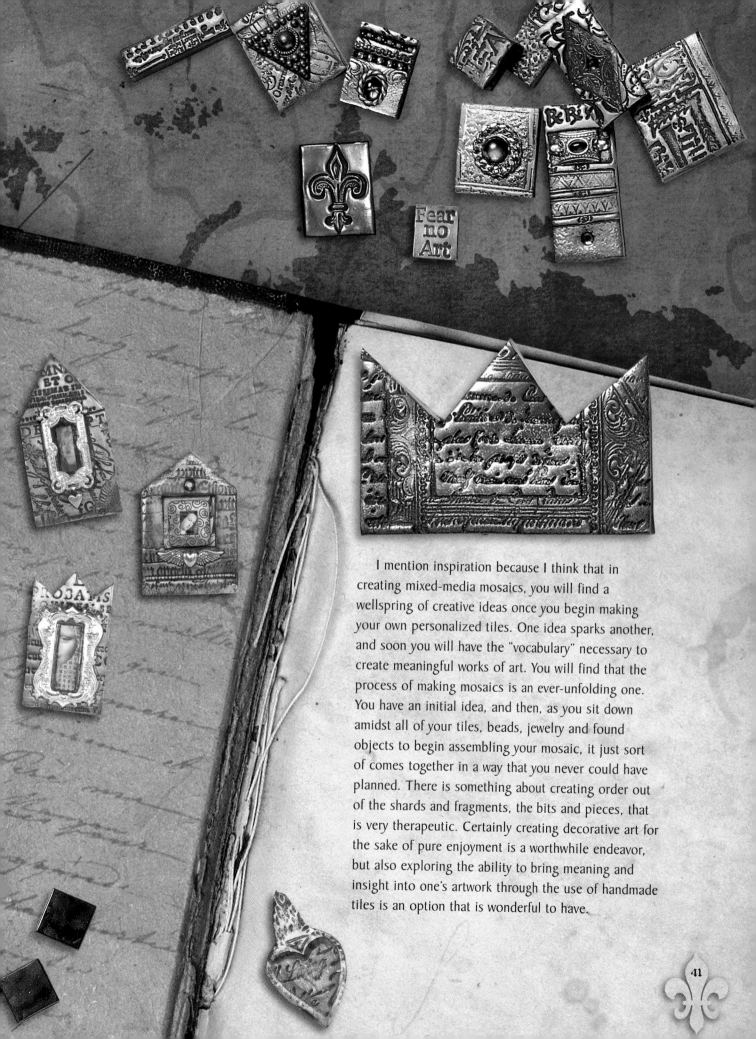

I mention inspiration because I think that in creating mixed-media mosaics, you will find a wellspring of creative ideas once you begin making your own personalized tiles. One idea sparks another, and soon you will have the "vocabulary" necessary to create meaningful works of art. You will find that the process of making mosaics is an ever-unfolding one. You have an initial idea, and then, as you sit down amidst all of your tiles, beads, jewelry and found objects to begin assembling your mosaic, it just sort of comes together in a way that you never could have planned. There is something about creating order out of the shards and fragments, the bits and pieces, that is very therapeutic. Certainly creating decorative art for the sake of pure enjoyment is a worthwhile endeavor, but also exploring the ability to bring meaning and insight into one's artwork through the use of handmade tiles is an option that is wonderful to have.

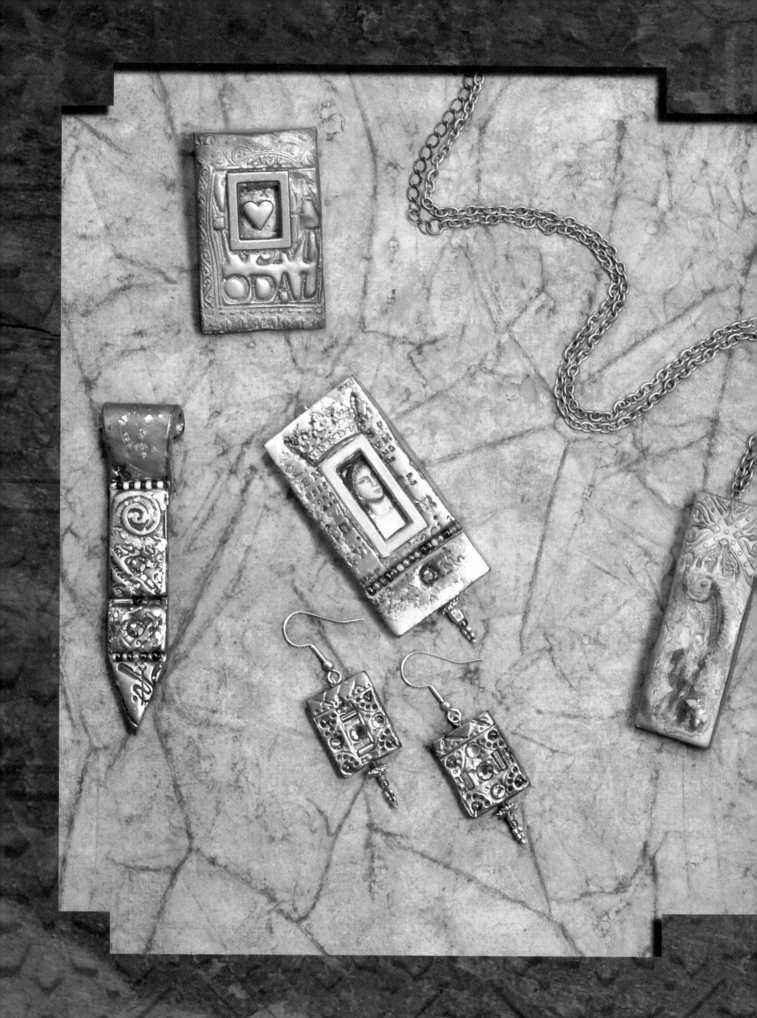

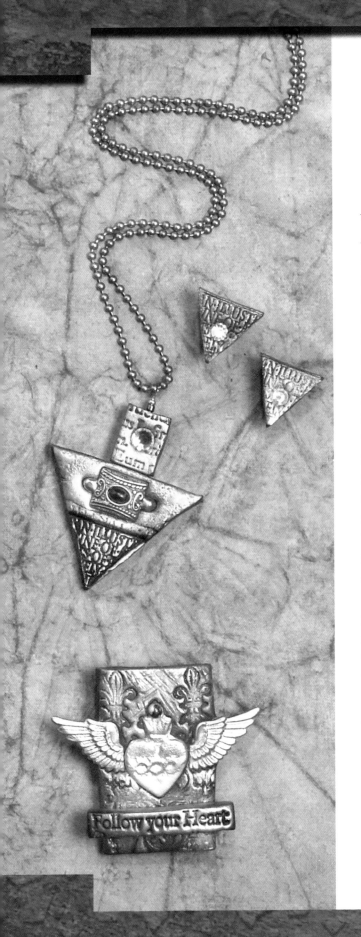

JEWELRY

WHEN I WAS FIRST
APPROACHED TO WRITE
THIS BOOK, MAKING
JEWELRY WAS A HOT TOPIC OF
CONVERSATION. I WASN'T CURRENTLY
MAKING JEWELRY, THOUGH I HAD IN THE PAST.
REMEMBER THE BUTTONS? WELL, THEY BECAME
BUTTON COVERS AND EARRINGS. MANY YEARS
HAD PASSED SINCE I DABBLED IN JEWELRY, AND
I WAS AGAINST INCLUDING IT IN THIS BOOK.
HOWEVER, A SURPRISING THING HAPPENED:
WITHOUT REALIZING IT, MY EXPLORATIONS IN
BOTH CREATING WINDOWS IN CLAY AND BEADING
IN CLAY LED ME STRAIGHT TO JEWELRY PIECES
ONCE AGAIN. THE TILES THAT EVOLVED FROM THIS
EXPERIMENTATION BECAME TINY RELIQUARIES.
THE BEADED TILES BECAME EARRINGS AND
PENDANTS. THIS IS THE BEGINNING OF A NEW
CHAPTER IN THE EVOLUTION OF MY WORK.

THE PROJECTS IN THIS CHAPTER ARE
JUST GLIMPSES INTO THE POSSIBILITIES THAT
POLYMER CLAY HOLDS. I HAVE ALWAYS LOVED
THE INTRICATE BEADED AND METAL WORK OF
VARIOUS JEWELRY ARTISTS, AND SO TO BE ABLE TO
CREATE PIECES THAT HAVE THE LOOK OF PRECIOUS
METALS BUT ARE ACTUALLY CLAY IS A NATURAL
EXTENSION OF THE WORK I HAD BEEN DOING
IN CREATING SHRINES AND ICONS OUT OF CLAY.
MY ARTWORK HAS GOTTEN SMALLER AND MORE
INTRICATE—JEWELRY IS A PERFECT FIT FOR WHERE
SOME OF MY TILES WERE GOING. YOU WILL BE
AMAZED BY THE EASE OF WHAT YOU CAN DO WITH
A SMALL BALL OF CLAY AND JUST A FEW TOOLS,
WITHOUT HAVING A LAPIDARY DEGREE.

RELIQUARY PIN

MATERIALS

Sculpey
rolling pin
wax paper
clay blade
brass frame
frame stamp
small square stamp
Quinacridone Gold acrylic paint
Spanish Copper Rub 'n Buff
Silver Rub 'n Buff
heart-shaped brad or
other embellishment
pin backing
jewelry glue
Weldbond glue or epozy
rag
roasting pan
binder clips

This little reliquary is essentially a highly embellished tile! It was working with three-dimensional windows in clay that evolved into making tiles that became jewelry pieces. Not to say that this pin couldn't function as a tile in a cool mosaic. Once again, there are endless possibilities for what can be placed inside the center of the frame, from pieces of jewelry to a tiny collage to a three-dimensional object that protrudes from the center. This pin also demonstrates how using Sculpey white clay rather than Premo! can create different looks, so always experiment with how various clays create interesting surfaces.

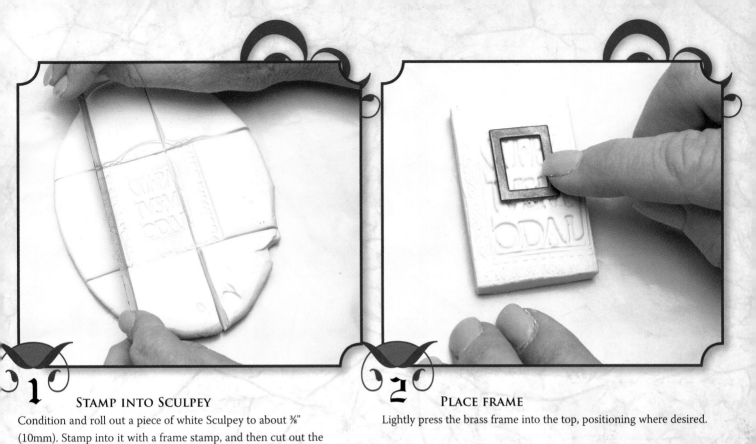

STAMP INTO SCULPEY

Condition and roll out a piece of white Sculpey to about ⅜"
(10mm). Stamp into it with a frame stamp, and then cut out the
fragment that you wish to use.

PLACE FRAME

Lightly press the brass frame into the top, positioning where desired.

INDENT CLAY AND TRIM

Using a small square stamp, push an indentation into
the space inside where the frame was marked.

APPLY GOLD WASH

Trim the edges of the piece again, where it spread out a bit from
all of the pressing. Bake the piece as directed. After it has cooled,
cover the baked piece with a wash of Quinacridone Gold, and
make sure paint seeps into all of the crevices.

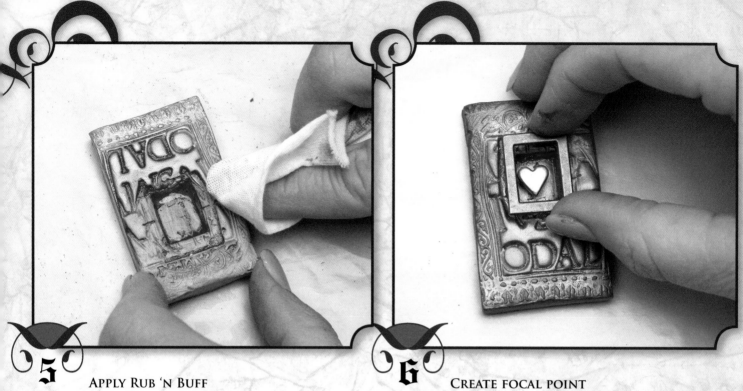

5 APPLY RUB 'N BUFF

Gently rub off all of the excess paint with a rag, then let dry.
Mix a bit of Spanish Copper Rub 'n Buff in with some Silver
Rub 'n Buff to create a warm silver, and rub it gently over the
entire surface.

6 CREATE FOCAL POINT

Find an embellishment for the window, such as a heart-shaped
brad, and glue it in, using jewelry glue. Glue the metal frame over
the opening as well.

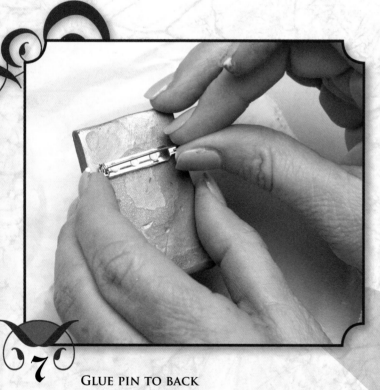

7 GLUE PIN TO BACK

Finally, using Weldbond glue or epoxy, glue a pin backing to the back.

FLECKS OF SILVER
PENNANT NECKLACE

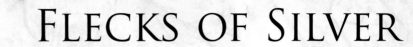

MATERIALS

purple Premo! clay

rolling pin

wax paper

silver leaf

rubber stamp

clay blade

silver mica powder

gold mica powder

paintbrush or dowel (optional)

stir stick

needle tool

beads

rhinestone

pencil with eraser

roasting pan

binder clips

his was one of the very first designs that I created that became a jewelry piece. I very seldomly use a rubber stamp in its entirety; instead I like using just a fragment of a stamp, often combining it with a different stamp. The banner pendant uses just a slim portion of a Michelle Ward stamp, my favorite part of the large stamp with the spiral at the top. I used one long piece of clay to make both the pennant and the bale. This long shape is perfect for creating rows of beads.

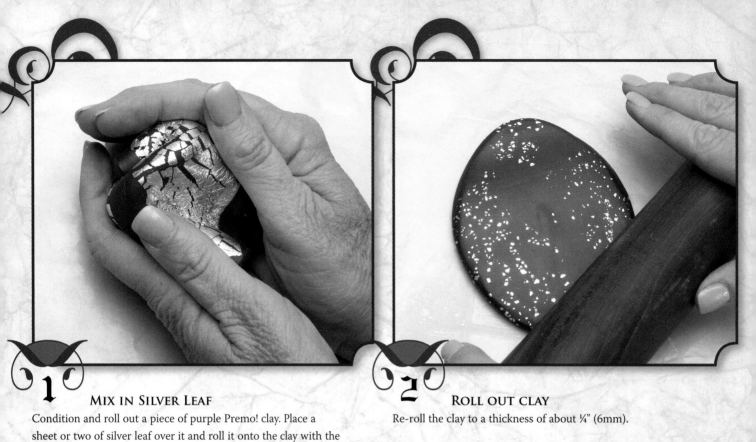

1 MIX IN SILVER LEAF

Condition and roll out a piece of purple Premo! clay. Place a sheet or two of silver leaf over it and roll it onto the clay with the rolling pin. Then wad the clay up in a ball.

2 ROLL OUT CLAY

Re-roll the clay to a thickness of about ¼" (6mm).

3 STAMP IMAGE

Stamp into the clay with a stamp that has a variety of textures to it.

4 TRIM TO DESIRED SHAPE

Trim a long shape out of the clay, making it pointed on one end.

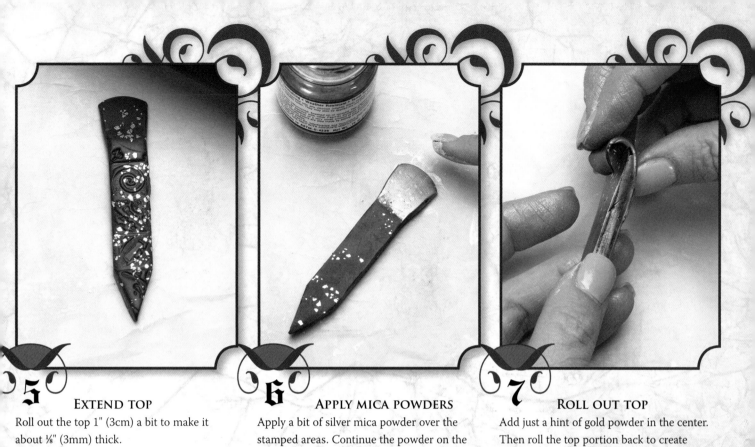

5
EXTEND TOP

Roll out the top 1" (3cm) a bit to make it about ⅛" (3mm) thick.

6
APPLY MICA POWDERS

Apply a bit of silver mica powder over the stamped areas. Continue the powder on the back and the sides of the piece as well.

7
ROLL OUT TOP

Add just a hint of gold powder in the center. Then roll the top portion back to create a bale for a chain. (Use a paintbrush or a dowel, if easier.)

8
BEAD CLAY

Impress a series of channels down the length of the front, using a stir stick. Using a needle tool, begin adding rows of beads to the indented lines. Here, I have alternated long beads with short ones.

9
PUSH IN RHINESTONE

Finally, add a rhinestone to finish things off, pushing it in with a pencil eraser. Bake as directed.

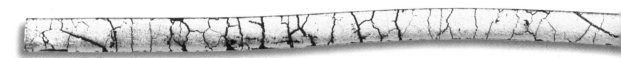

This mirror was created a few years ago when my father was succumbing to the ravages of Alzheimer's disease. He had been diagnosed seven years prior to his passing, so the subtitle for this piece, "The Long Goodbye," is very apt. As I began working on the tiles for this piece, about a week before my father passed away, I realized that I was making it more for myself, as a way to express my feelings during this difficult time. It is filled with words and images that perfectly summarized what we were both going through.

The mirror really is an altar to my father. At the top of the piece is a Mexican tin niche that holds my father's obituary with a photograph of when he was vital and healthy. Below the niche is a little pouch to hold a few of his ashes. On the left side is another pouch that contains a poem I wrote when my father was first diagnosed with Alzheimer's

disease. On the right side of the mirror is a small window opening that has a photograph of my dad when he was younger. Around the inside edge, closest to the actual mirror, are tiny magnetic words that describe my feelings about his disease and his passing, such as "courage, warm heart, comfort, still mending." At the very bottom of the mirror is a tin heart symbolizing a daughter's love for her father.

Using a mirror as the foundation to create this mixed-media mosaic was intentional, because I am a reflection of my father. I love that it contains important things about him all in one piece. This altar hangs in a very prominent location in our home, and, while it serves its function as a mirror, it has a greater purpose. This mixed-media mosaic mirror, rather than being an object that is depressing or somber, is actually a joyous and daily reminder of the person he was.

FATHER

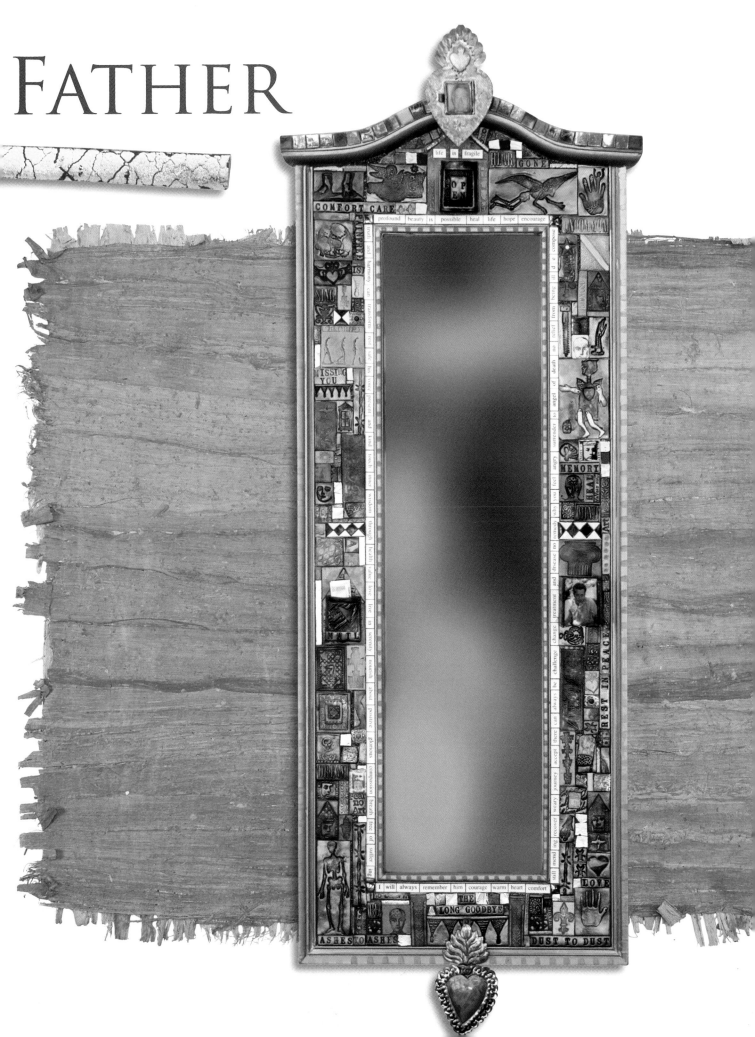

FIT FOR A QUEEN
Earring and Pendant Set

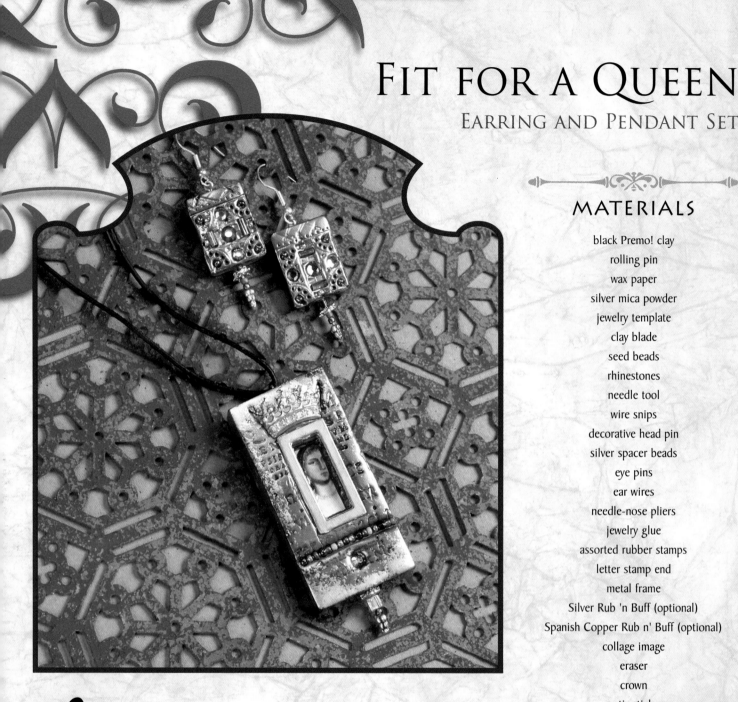

MATERIALS

black Premo! clay

rolling pin

wax paper

silver mica powder

jewelry template

clay blade

seed beads

rhinestones

needle tool

wire snips

decorative head pin

silver spacer beads

eye pins

ear wires

needle-nose pliers

jewelry glue

assorted rubber stamps

letter stamp end

metal frame

Silver Rub 'n Buff (optional)

Spanish Copper Rub n' Buff (optional)

collage image

eraser

crown

stir stick

silver embossing powder

heat gun

roasting pan

binder clips

Ayala Bar is an Israeli jewelry designer whose work I greatly admire and who has been extremely influential in my desire to add beads to clay. I love her intricate designs, and I wanted to create a similar ornate look using polymer clay. I used an old necklace that I had as a template to begin this jewelry set. Again, it is always useful to be on the lookout for interesting jewelry parts to use both in your mosaics and as a template or mold.

EARRINGS

One of my favorite techniques with polymer clay is creating faux metal looks, which really works well in jewelry design. I have experimented with precious metal clay and, while I love the look, regular polymer clay is a much more affordable alternative! In these beaded earrings I have used just one link of the necklace as the template for the earrings.

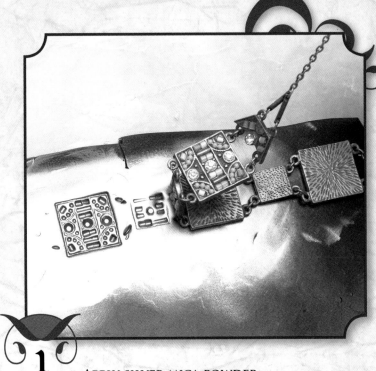

1 APPLY SILVER MICA POWDER

Condition and roll out black Premo! clay to ⅛" (3mm) thickness. Liberally rub on some silver mica powder, and then press the necklace link into the clay.

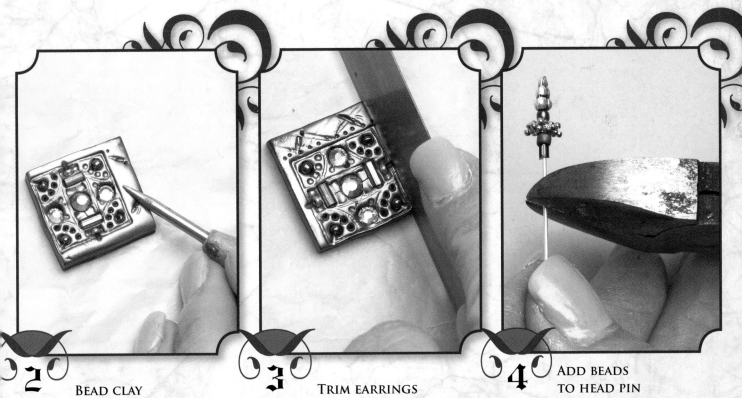

2 BEAD CLAY

Cut out two shapes for the earrings, leaving a little extra space around each one to trim down later. Add beads and rhinestones where desired, and then create a little row of dots on top and use the needle tool to create a cross-hatch pattern.

3 TRIM EARRINGS

Trim down the shapes to their final size, and spread more silver powder on the sides and the back.

4 ADD BEADS TO HEAD PIN

Thread one seed bead onto a decorative head pin, then add an ornate silver spacer and two more seed beads. Snip the pin down so that about ½" (13mm) is left above the beads.

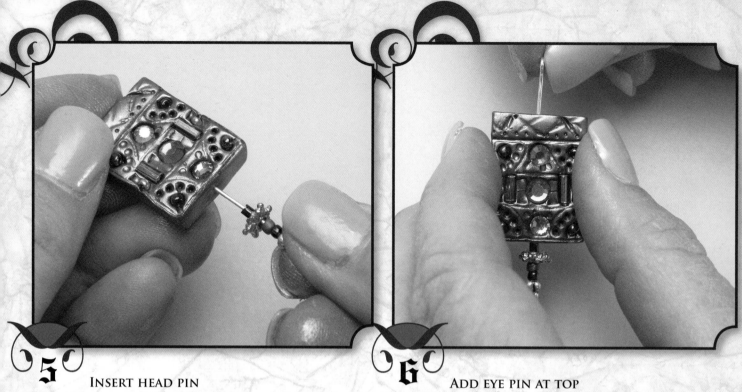

5 INSERT HEAD PIN

Carefully insert the wire into the center of the clay at the bottom of one piece.

6 ADD EYE PIN AT TOP

Snip an eye pin down to leave about ½" (13mm), then insert it into the top center of the piece.

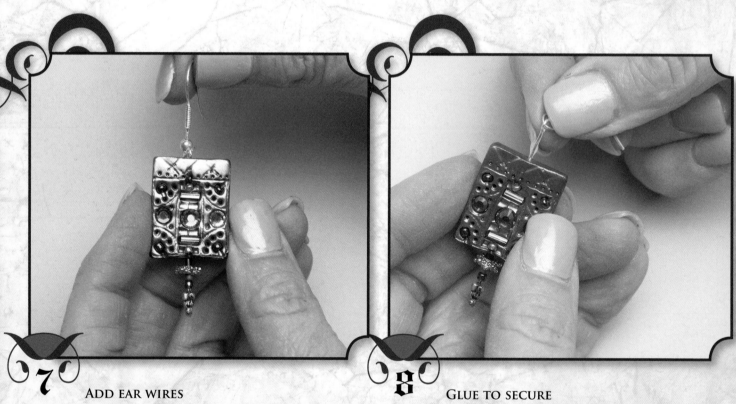

7 ADD EAR WIRES

Repeat for the other earring, and bake as directed. When cool, add an ear wire to each earring, with the help of needle-nose pliers.

8 GLUE TO SECURE

Lastly, pull the wire out of the clay, dip the wire in jewelry glue and reinsert it into the clay. Repeat steps 6 and 7 for the other earring.

PENDANT

Instead of using pre-made collage images, think of the possibilities for creating little shrine pendants using photos of your loved ones as the centerpieces. Better yet, make yourself the "Queen" (or King!) for the day and add your own image to give to someone special.

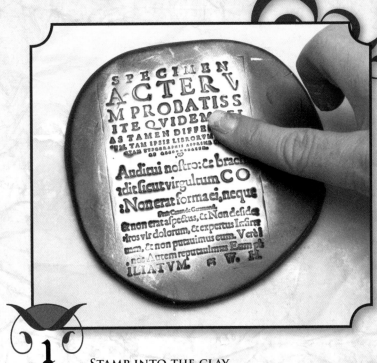

1 STAMP INTO THE CLAY

Condition and roll out a piece of black Premo! clay to ⅛" (3mm). Stamp into it with a text stamp, then rub on silver mica powder.

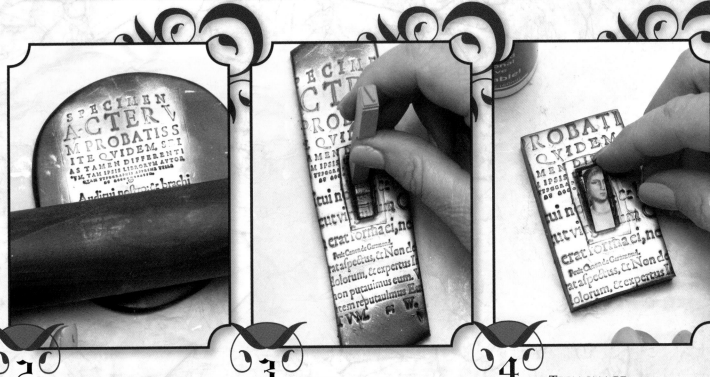

2 ROLL OVER IMAGE

With the rolling pin, gently roll out the raised areas of the stamp to flatten and create a softer look.

3 INDENT CLAY

If you don't already have a pewter frame for your piece, you can alter a gold one using a mixture of Silver Rub 'n Buff and Spanish Copper Rub 'n Buff. Gently press your frame onto the stamped clay where you want it, then remove it and use a small letter stamp to stamp a recess into the clay. You may need to make more than one impression to run the entire length of the frame opening.

4 TRIM IMAGE

Trim the image you wish to use to the size of the recessed opening. Using jewelry glue, glue in the image. Burnish it down with your eraser.

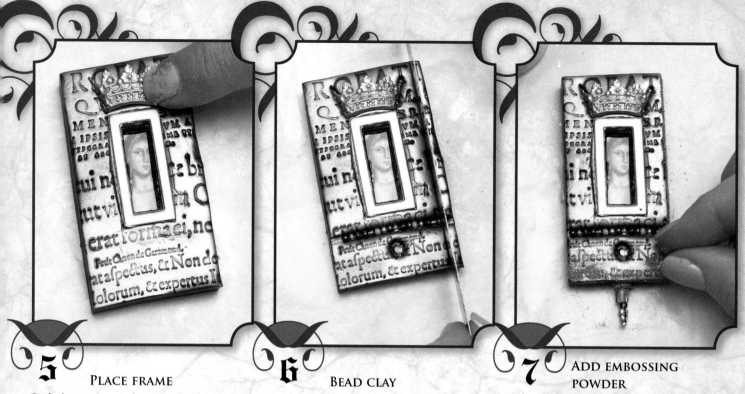

5 PLACE FRAME

Push the pewter window into the clay over the image. Also, push a small crown into the clay, at the top of the frame.

6 BEAD CLAY

Create an indentation for a row of beads, using a stir stick. Using jewelry glue, glue a row of random beads into the space. After everything has been pushed into your piece, trim it down a final time, using a clay blade.

7 ADD EMBOSSING POWDER

Thread one seed bead onto a decorative head pin, then add an ornate silver spacer and two more seed beads. Snip the pin down so that about ½" (13mm) is left above the beads and insert it into the bottom of the piece. Snip an eye pin down to leave about ½" (13mm), then insert it into the top center of the pennant. Sprinkle silver embossing powder over the sides of the piece, and gently rub it in. Also rub a bit around the perimeter on the front.

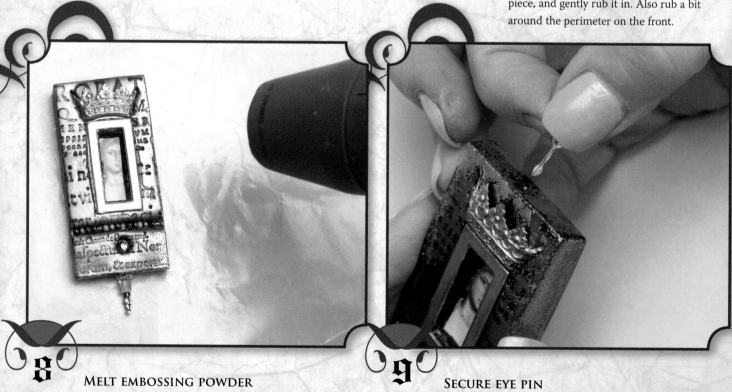

8 MELT EMBOSSING POWDER

Heat the powder to melt it with a heat gun. This will harden the edges of your clay, but don't be alarmed.

9 SECURE EYE PIN

Bake as directed. Pull out the eye pin wire, dip it in some glue and then reinsert it into the clay.

TRIANGLE SET

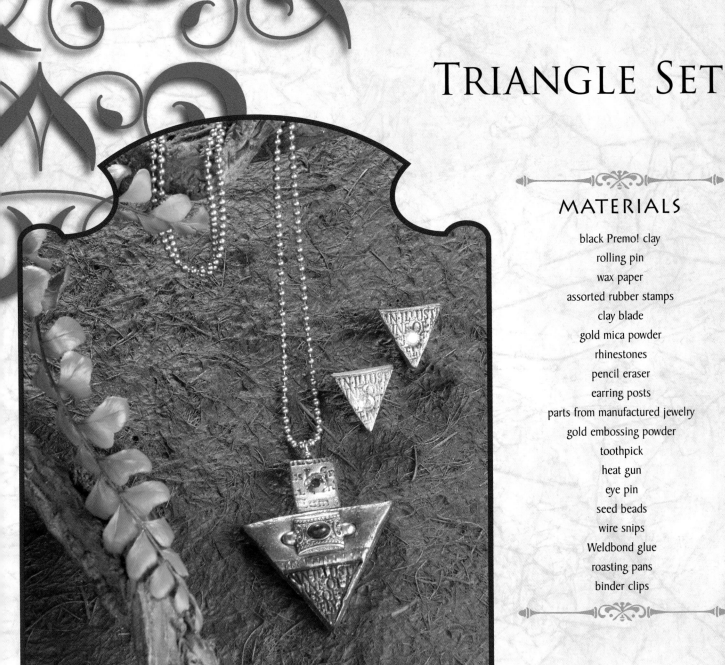

MATERIALS

black Premo! clay

rolling pin

wax paper

assorted rubber stamps

clay blade

gold mica powder

rhinestones

pencil eraser

earring posts

parts from manufactured jewelry

gold embossing powder

toothpick

heat gun

eye pin

seed beads

wire snips

Weldbond glue

roasting pans

binder clips

Oh, the shapes you can create. Let your mind wander and play. Explore different shapes by cutting the clay on the diagonal, like this triangle pendant and earrings. You may even want to experiment with round shapes. I never really work with curves or circles because I am just wired for straight, geometric lines, but that's just me. Free up some time to explore how shapes influence your overall design.

EARRINGS

Repeating one element of a stamped design is a great way to create a set of matching jewelry pieces. Here, I used a small fragment of a stamp for the earrings and expanded on it to make the matching pendant. The stamp is a portion of a banner stamp from Zettiology.com.

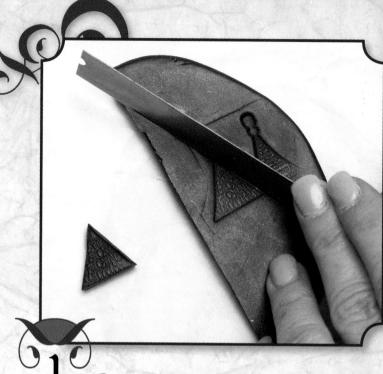

1 CUT OUT STAMPED IMAGE
Condition and roll out some black Premo! clay and stamp into it with a banner stamp. Cut out two triangles from the banner shapes. These will be the earrings.

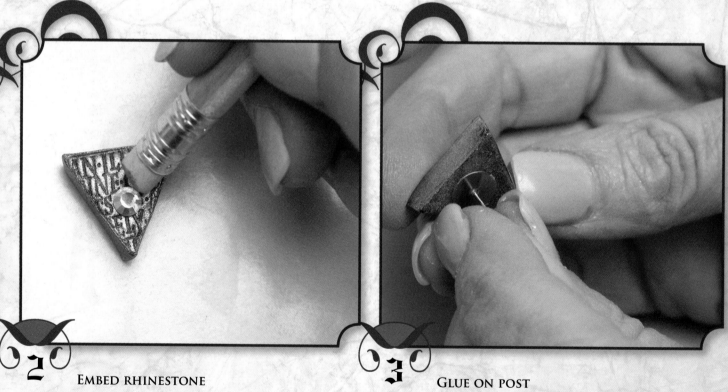

2 EMBED RHINESTONE
Cover the shapes with gold mica powder and push a rhinestone into the center of each earring. Bake as directed.

3 GLUE ON POST
Using Weldbond, glue an earring post to the back of each piece.

PENDANT

Pendants are great vehicles for experimentation because they have larger surface areas to design, which allows for greater creativity. This contemporary-looking pendant is perfect to wear by itself or with the earrings for a complete look. In this necklace, I have also embedded a piece of manufactured jewelry (a piece from a necklace I found at a swap meet) for added dimension. So be looking for those possibilities to create polymer clay jewelry by combining pieces of costume jewelry.

1 CUT OUT PENDANT SHAPE

Cut a larger triangle out of the clay, incorporating a portion of a banner piece, but leaving a larger amount plain. This will be the pendant.

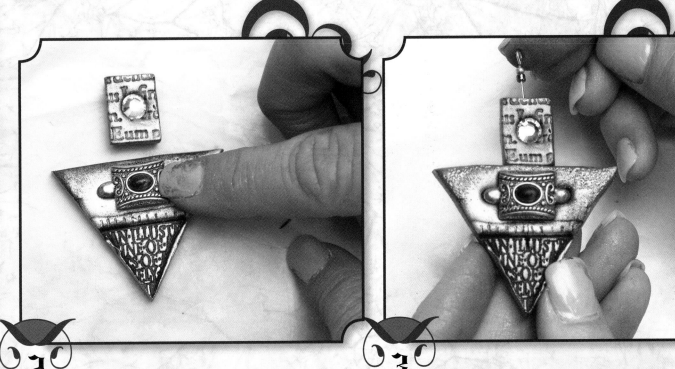

2 EMBED JEWEL

Rub gold mica powder over the pendant piece. Roll out some more clay and stamp into it with a text stamp. Cut a small square out of the clay, rub gold mica powder over it, and then push in a crystal to the center. Push a larger jewel into the center of the pendant.

3 FINISH WITH EMBOSSING POWDER

Push a hole into the top center of the pendant, using a toothpick, and then remove. Rub gold embossing powder over the top edge of the pendant. Heat with a heat gun to melt the powder. Make another hole all the way through the square bead, using an eye pin that you first thread a bead onto. Then push the pin into the top of the pendant piece.

SACRED HEART PIN

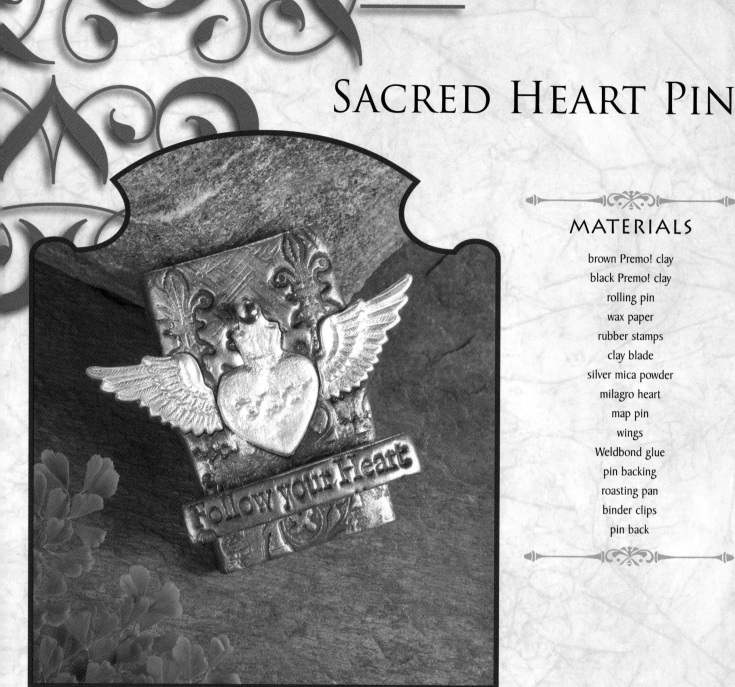

MATERIALS

brown Premo! clay

black Premo! clay

rolling pin

wax paper

rubber stamps

clay blade

silver mica powder

milagro heart

map pin

wings

Weldbond glue

pin backing

roasting pan

binder clips

pin back

I certainly have a thing for hearts—but then add a crown or wings to it and I'm over the moon! By combining various found jewelry pieces you can make up your own designs and put your favorite things all together in one piece, as I have done in this sacred heart pin. I have also made pieces in which I pushed these separate elements into clay to create one tile.

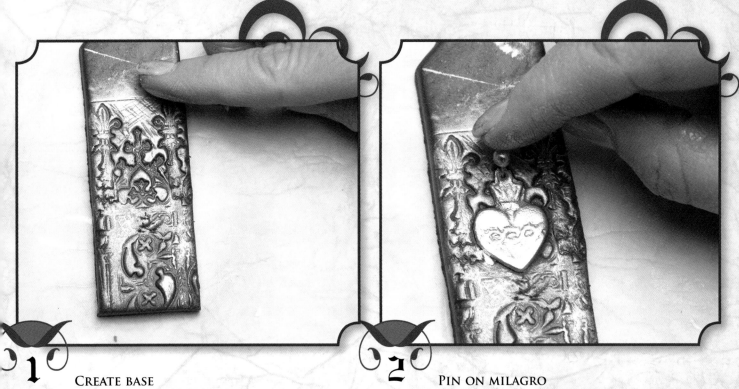

1 · CREATE BASE

Condition and roll out some brown Premo! clay. Stamp into the clay with a background stamp and trim it to the width you would like your pin to be. Rub silver mica powder over the clay surface.

2 · PIN ON MILAGRO

Press a heart milagro into the clay. Push a silver map pin through the charm's hole to visually fill it in and to further secure it.

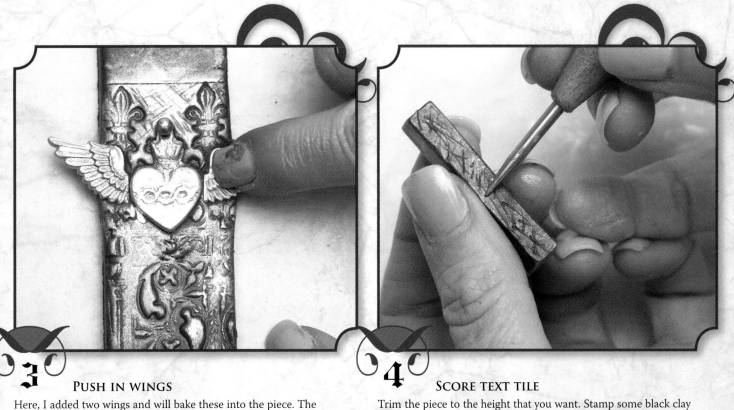

3 · PUSH IN WINGS

Here, I added two wings and will bake these into the piece. The indentations will make it easier to glue them on, if necessary, for better adhesion after baking.

4 · SCORE TEXT TILE

Trim the piece to the height that you want. Stamp some black clay with a text stamp, and cut out the text that you wish to use. Then rough up the back a bit using a needle tool to give it some tooth.

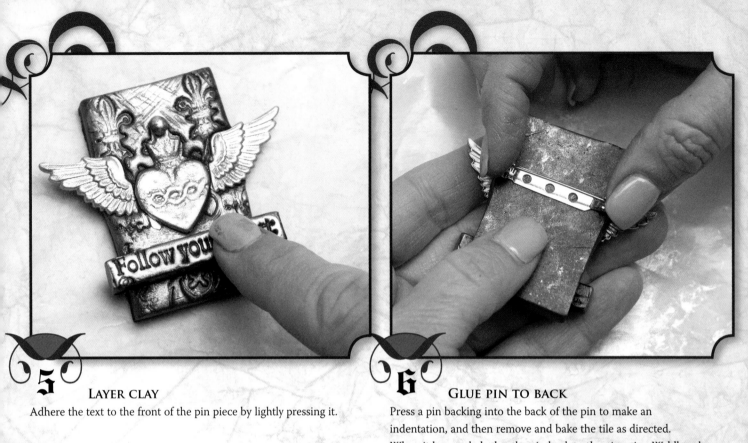

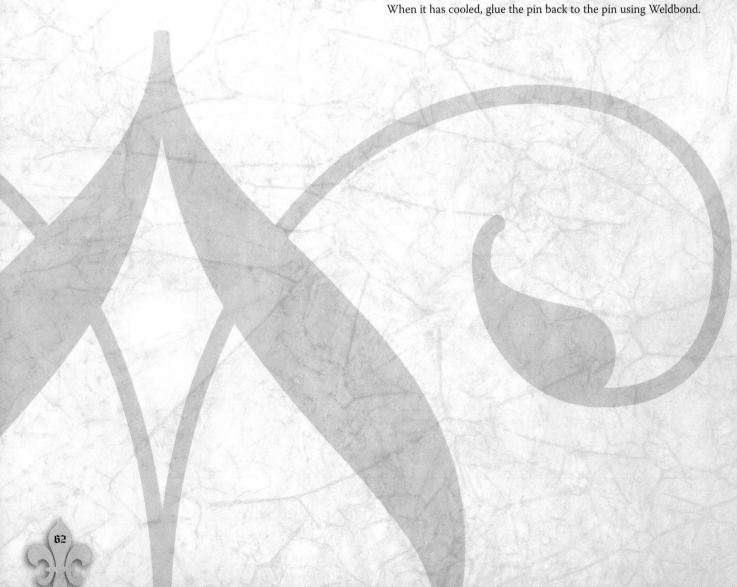

5 LAYER CLAY

Adhere the text to the front of the pin piece by lightly pressing it.

6 GLUE PIN TO BACK

Press a pin backing into the back of the pin to make an indentation, and then remove and bake the tile as directed. When it has cooled, glue the pin back to the pin using Weldbond.

TRANSFER PENDANT

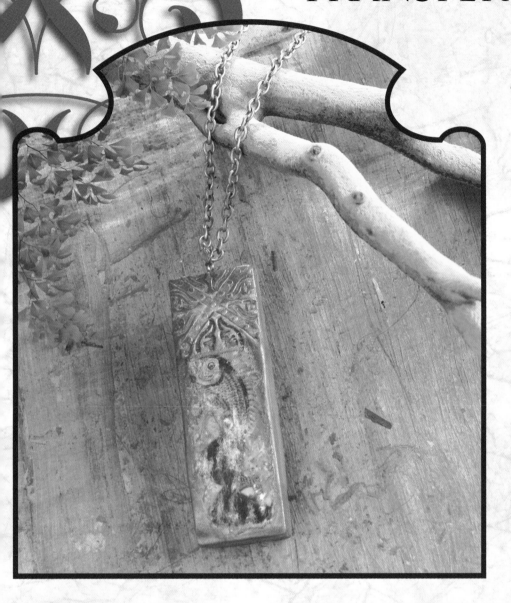

The wonderful world of transfers is an area I am just beginning to explore, and, of course, I have to transfer onto a tile! This technique really does open the creative floodgates when you think about the limitless possibilities for combining tiles with images. It is also a way to add another level of interest on tile surfaces to use in your mixed-media mosaics. The process that I demonstrate in this project uses the simplest of transfer methods, but hey, it works!

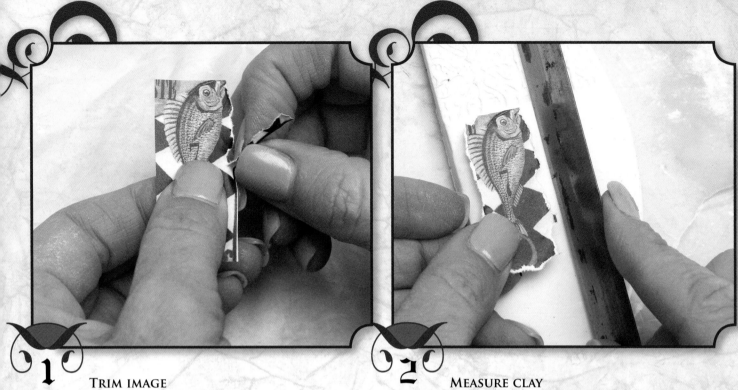

1 TRIM IMAGE

Pick an image to transfer and tear the edges of it to soften it a bit.

2 MEASURE CLAY

Condition and roll out some white Sculpey clay to about ⅜" (10mm) thickness. Stamp with something having a straight edge at one end of the clay. Trim the clay down to a rectangle so that the stamped texture is at the top and there is enough smooth clay at the bottom to accommodate the image.

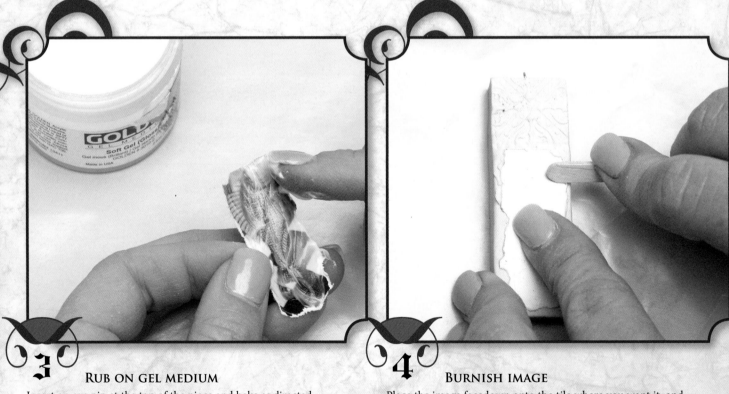

3 RUB ON GEL MEDIUM

Insert an eye pin at the top of the piece and bake as directed. When the tile has cooled, you can prepare to do your transfer. Begin by rubbing gel medium onto the front of the image.

4 BURNISH IMAGE

Place the image facedown onto the tile where you want it, and press it lightly. Then burnish the image to the tile, using a craft or stir stick.

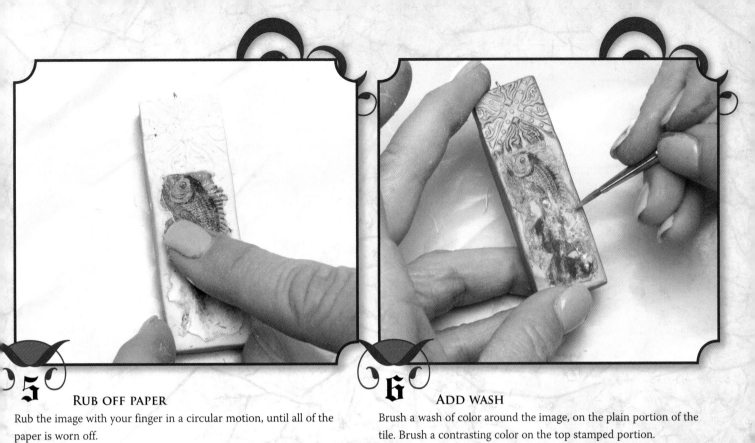

5 RUB OFF PAPER

Rub the image with your finger in a circular motion, until all of the paper is worn off.

6 ADD WASH

Brush a wash of color around the image, on the plain portion of the tile. Brush a contrasting color on the top stamped portion.

7 ADD RUB 'N BUFF

Apply some Green Jade Rub 'n Buff on all sides.

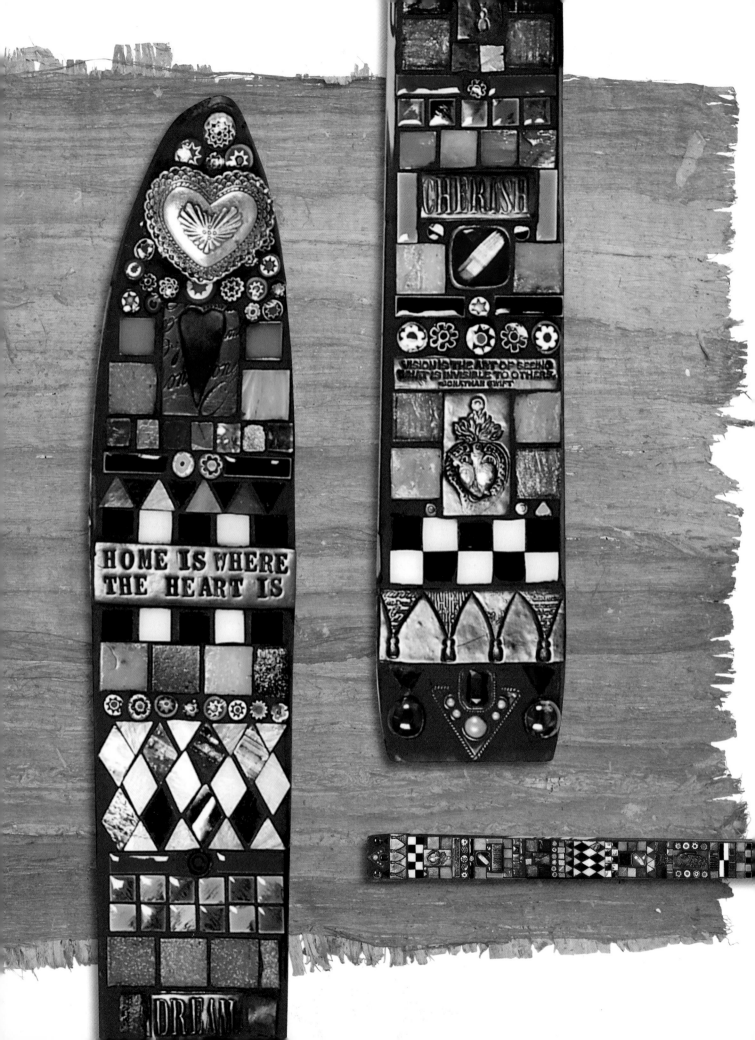

LET IT SNOW

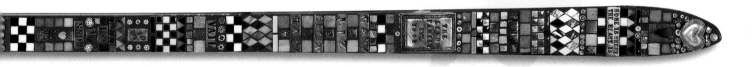

My brother and his family live in Vail, Colorado; they are never short on company! Last December, our family descended on their home to spend the holidays skiing together. I began trying to think of a gift for them that would express our appreciation for their generous hospitality. I spied my old straight skis in a corner of the garage and I was struck with the perfect idea—mosaic a set of skis!

It was my husband who actually suggested mosaic-ing just one ski so that it would seem more like an art piece rather than the traditional crossed set of skis that are so typical in mountain homes. As I began making the many tiles for this gift, I was very happy that he suggested only making one ski!

The long single ski format functions as a talisman that hangs on a narrow strip of wall by their front door, bringing them good luck! The ski is embellished with tiles that have significance to my brother and his family. There are tiles that are personalized with their names and when they became established as a family. The ski is also embellished with jewelry pieces that are personal symbols, such as the heart at the top of the ski.

This ski demonstrates the ability to alter an everyday object into a meaningful piece of art. I know lots of people who have created mosaics on musical instruments that are just beautiful. As you look around your house or garage, think of all the possibilities that are out there—really just about anything with a surface has the potential for transformation into a mixed-media mosaic!

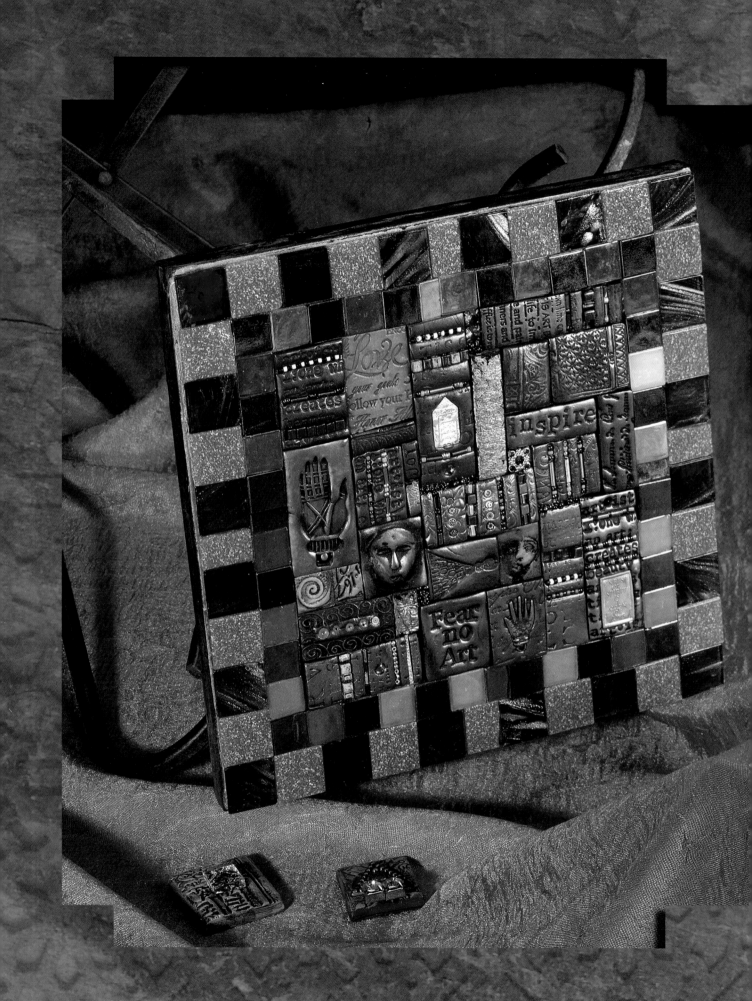

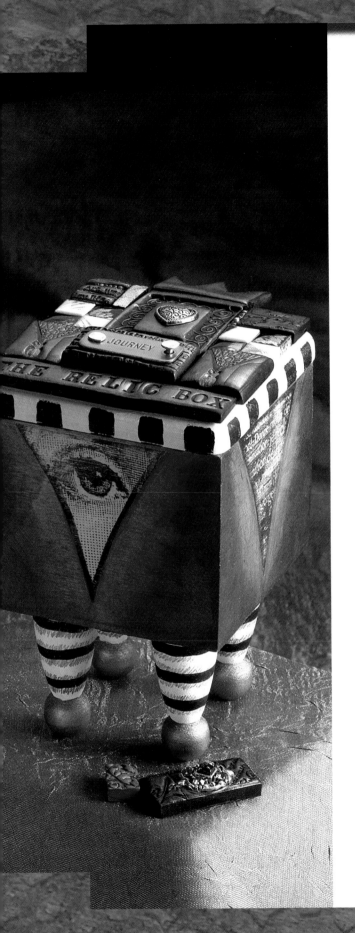

TABLES AND BOXES

ONCE YOU'VE BEGUN MAKING BATCHES OF TILES
AND COLLECTING COOL LITTLE DOODADS, YOU
WILL ALSO DEVELOP A KEEN EYE FOR ALL OF
THE POSSIBLE SURFACES THAT CAN BE ADORNED
BY THESE TILES. THIS CHAPTER IS ALL ABOUT
TRANSFORMING EVERYDAY ITEMS INTO BEAUTIFUL
MOSAIC ART PIECES. RUMMAGING AROUND FLEA
MARKETS, SWAP MEETS AND GARAGE SALES IS SURE
TO NET YOU A FEW GREAT FINDS JUST WAITING
TO BE EMBELLISHED. THIS IS THE INTERSECTION
WHERE FORM AND FUNCTION COME TOGETHER!
CREATING FUNCTIONAL ART IS A WAY TO REALLY
CONNECT WITH PEOPLE. THERE IS SOMETHING
ABOUT A BOX THAT PEOPLE REALLY RESPOND
TO. I THINK IT IS BECAUSE BOXES ARE VESSELS
INTENDED TO CARRY SOMETHING ELSE AND
THAT SOMETHING ELSE CONJURES UP ALL KINDS
OF POSSIBILITIES. INVARIABLY THE TOPS ARE
LIFTED OFF TO BE EXAMINED INSIDE, BUT IT IS
THE FACT THAT IT IS A PIECE OF ART FIRST, AND
THEN SOMETHING FUNCTIONAL, THAT RESONATES
WITH PEOPLE. LIKEWISE, THE MOSAIC TABLES
IN THIS CHAPTER ARE EQUALLY DELIGHTFUL
BECAUSE THEY ARE BEAUTIFUL TO BEHOLD
BUT CAN ALSO BE AN OBJECT THAT IS USEFUL.
CREATING FUNCTIONAL MOSAIC PIECES IS A
WAY TO BRING ARTFUL LIVING TO THOSE WHO
MAY BE RELUCTANT TO BUY ART OTHERWISE.

A JEWEL OF A TABLE

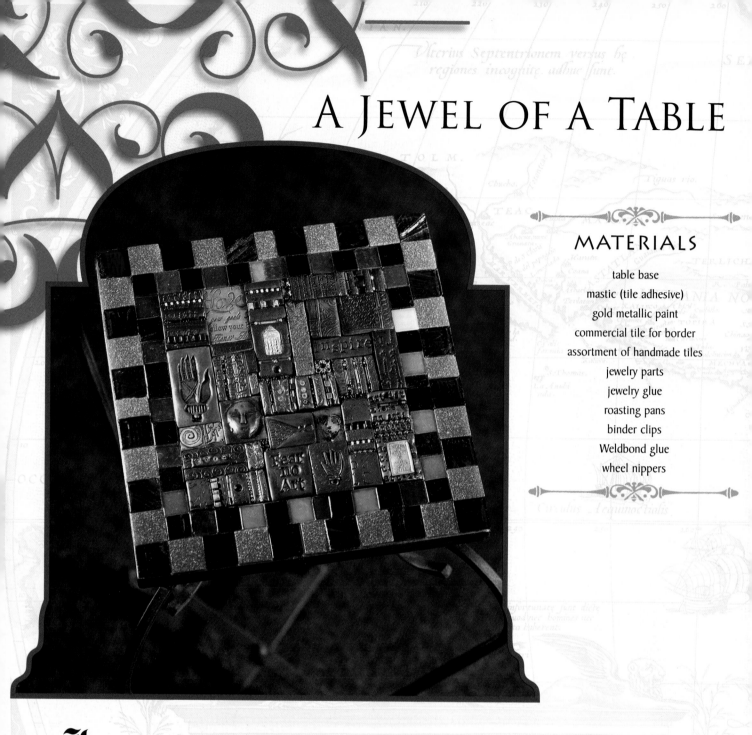

MATERIALS

table base
mastic (tile adhesive)
gold metallic paint
commercial tile for border
assortment of handmade tiles
jewelry parts
jewelry glue
roasting pans
binder clips
Weldbond glue
wheel nippers

I enjoy searching for small decorative tables that can be embellished with intricate beaded and stamped tiles to create very special art pieces. These tables are so small that they inherently are viewed as art objects because there is barely enough room to place a coaster on top! Check out retail stores like Marshall's or T.J. Maxx for small end tables—there are plenty of them out there just waiting for an extreme makeover!

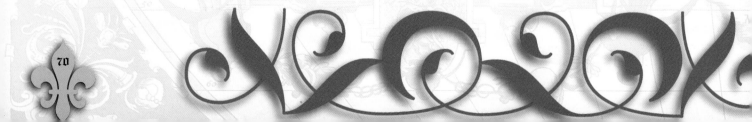

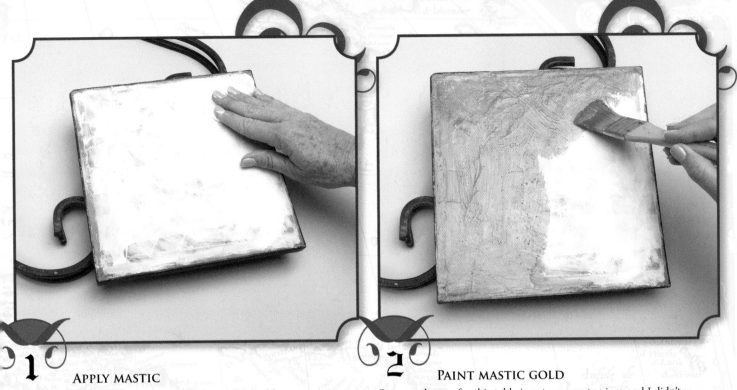

1 APPLY MASTIC

Begin by applying mastic to the original top of the table to create a ground for the tiles to adhere to.

2 PAINT MASTIC GOLD

Because the top for this table is not a separate piece and I didn't want to get overspray on the rest of the table, I chose to brush on gold metallic paint, instead of using spray paint.

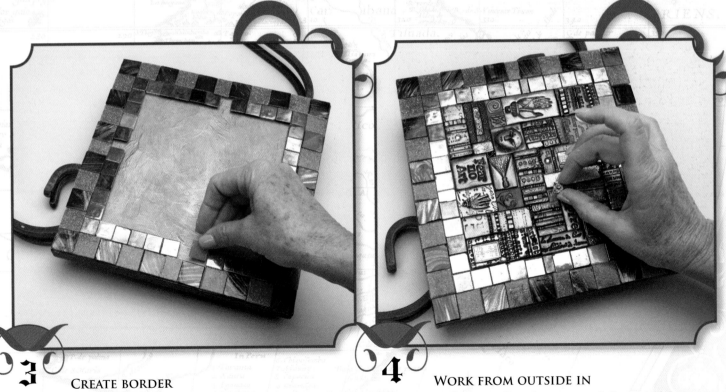

3 CREATE BORDER

When the paint is dry, begin gluing on the tiles. Start with the glass border tiles around the outside. Make a second row of glass tiles that are slightly smaller than the outer ones. Start in the corners and work your way toward the inside. If, when you get to the center, there is not enough room for an entire tile, you may need to snip one to fit. (See page 12.)

4 WORK FROM OUTSIDE IN

Now begin placing some of your larger stamped tiles around the edges, working from the outside toward the center, where it is easier to fit in small pieces such as jewelry and beads.

PRISM-PAINTED TABLE

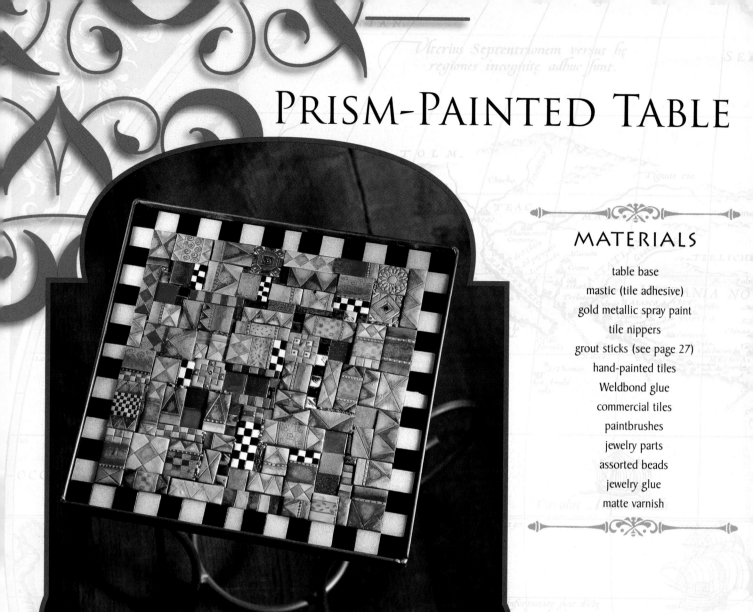

MATERIALS

table base
mastic (tile adhesive)
gold metallic spray paint
tile nippers
grout sticks (see page 27)
hand-painted tiles
Weldbond glue
commercial tiles
paintbrushes
jewelry parts
assorted beads
jewelry glue
matte varnish

Tables, being flat, are great surfaces to work on and, unlike walls or ceilings, you don't have to fight the forces of gravity. When sealed properly, hand-painted mosaic tabletops are functional as well as beautiful. (Not that you would want your creation covered up by a potted plant!) Beware and be patient; it takes quite a bit of time to paint enough tiles to cover a tabletop, but the end result is worth it. Remember, no pain, no gain! Here's a tip: Add commercial tile into the mix so you don't need as many hand-painted tiles—it really gives the tabletop a mixed-media look. Here I have used my favorite border, the black-and-white check that really shows off the painted tiles.

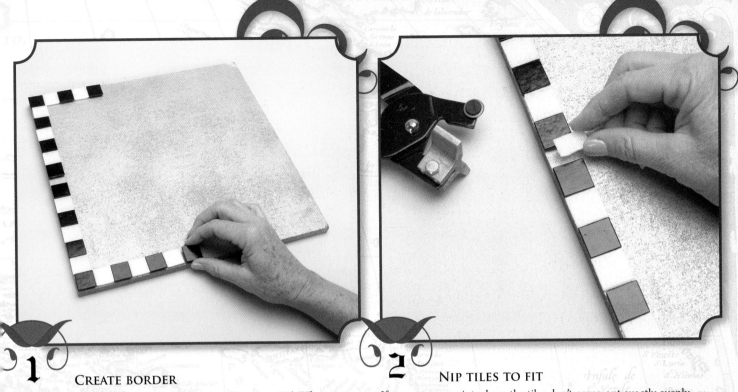

1 CREATE BORDER

Prepare the tabletop base with tile adhesive. (See page 10.) When the adhesive is dry, spray paint the base with gold metallic paint. When the paint is dry, you can begin gluing on the tiles. Start with a nice, straight frame of glass tiles around the perimeter of the base.

2 NIP TILES TO FIT

If you get to a point where the tiles don't come out exactly evenly with the shape of the base, you can trim a final tile down to fit.

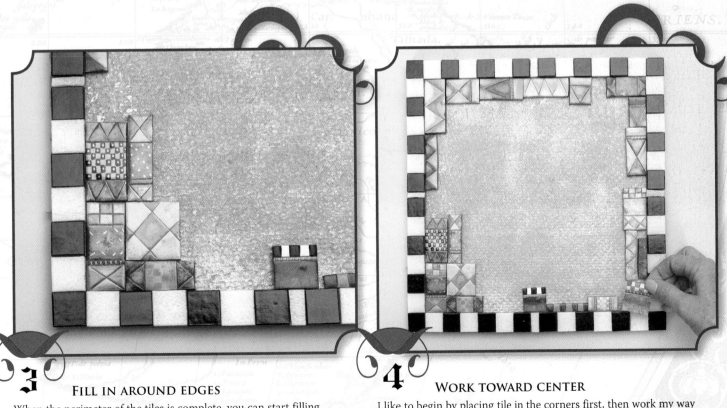

3 FILL IN AROUND EDGES

When the perimeter of the tiles is complete, you can start filling in the space with your hand-painted tiles.

4 WORK TOWARD CENTER

I like to begin by placing tile in the corners first, then work my way toward the center.

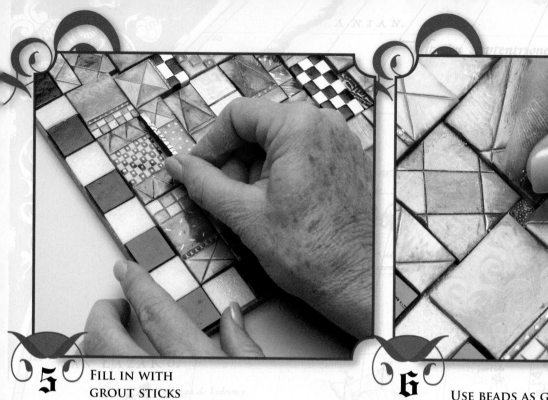

5 FILL IN WITH GROUT STICKS

When all of the tiles have been glued in, fill in any remaining small holes or gaps with grout sticks (see page 27) or . . .

6 USE BEADS AS GROUT

. . . seed beads work well for filling in the tiny gaps between tiles, creating a unique alternative to grouting.

TILE TIP

When selecting micro beads or seeds beads to fill in the gaps and cracks, select colors that will unify your overall piece, the way that grout would.

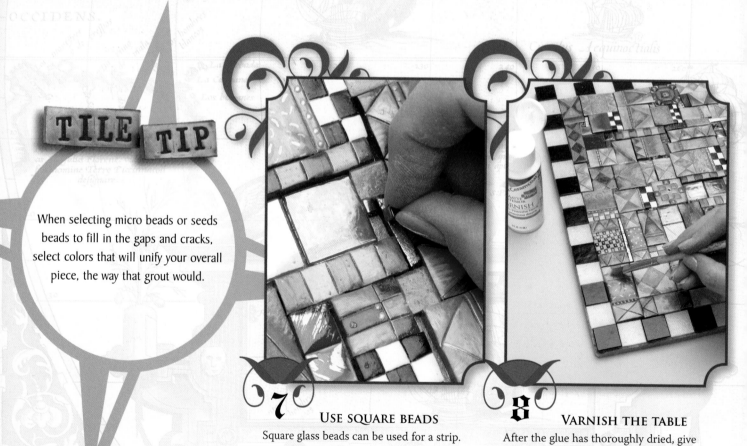

7 USE SQUARE BEADS

Square glass beads can be used for a strip.

8 VARNISH THE TABLE

After the glue has thoroughly dried, give the tabletop a coat of matte varnish. Brush each tile individually. There is no need to varnish the commercial tile.

RELIC BOX

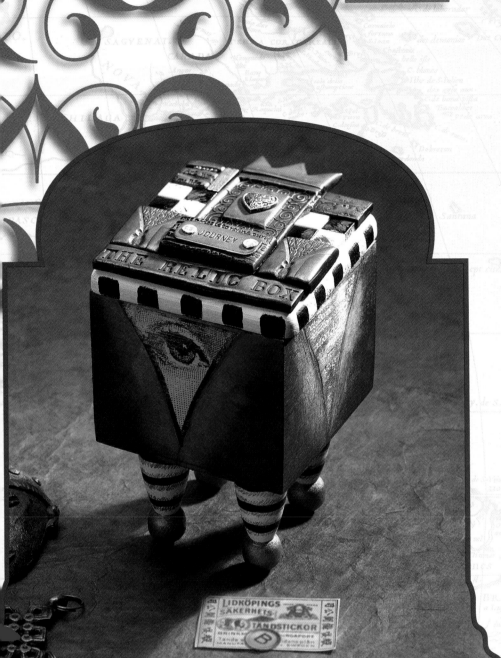

MATERIALS

wood box

wood legs

gold metallic spray paint

assorted rubber stamps

black ink pad (StazOn)

assorted acrylic paints

paint brush

black Premo! clay

rolling pin

wax paper

clay blade

mica powders

roasting pans

binder clips

stamped tiles

manufactured tiles (optional)

charms

tacks

metallic gold paint

fine paintbrush

grout sticks

jewelry parts

seed beads

Spanish Copper Rub 'n Buff

rag

tin snips

Weldbond glue

graphite pencil

I love boxes. They're great gifts for all occasions, especially when they are personalized (with alphabet stamps) for the lucky person who receives one. Always be on the lookout for unique legs to give your boxes. With legs, the lowly box is literally elevated to an art form! The Relic Box is one of my favorites, as it combines a variety of elements and techniques all wrapped up in one small box. Remember: Think outside the box!

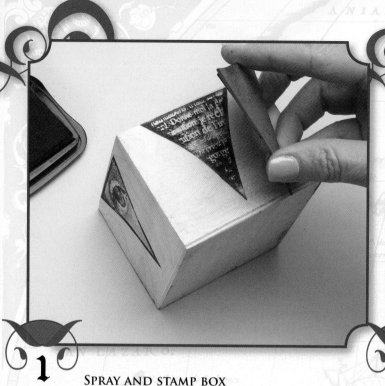

1 SPRAY AND STAMP BOX

Spray paint the interior of the box and the entire lid gold. Around the perimeter of the box, stamp the triangle stamp on the box using StazOn black ink. A different image can be stamped on each side. Leave the inside of the stamped image unpainted.

2 PAINT AREAS WHITE

Using a brush, paint the rim of the lid and the four legs white. You can leave the ball portion unpainted.

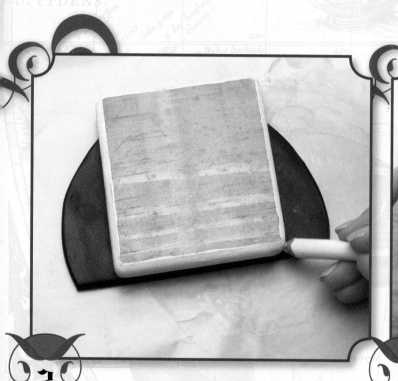

3 MEASURE BOX TOP

For this box, I know that I want to have a tile of text at the bottom, so I'm starting there. Condition and roll out some black Premo! clay to ⅛" (3mm) thickness. Use a clay blade to cut off one side. Lay the box on the clay and mark the width of the box on the clay.

4 CREATE TITLE

Stamp your word or phrase into the clay, using alphabet stamps or a word stamp. Rub some mica powder over the clay, and then trim the top off with the clay blade.

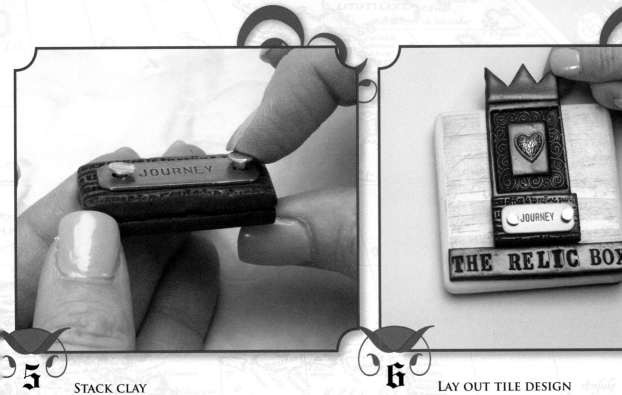

5 STACK CLAY

Next, to create a tile that is higher than the rest, stack two same-size pieces of clay and set a brass word charm on top of it. Then press two tacks into the holes of the charm to adhere the three pieces together.

6 LAY OUT TILE DESIGN

Stamp additional tiles with images and text, or use stamped tiles that you already have. To begin the design for the box, lay out the large elements first.

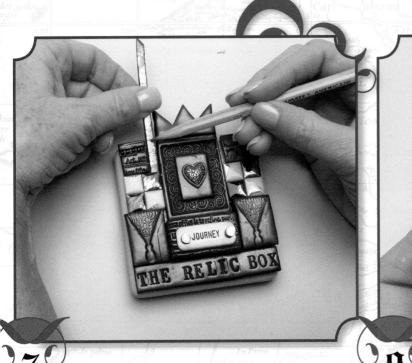

7 FILL IN THE GAPS

Glue those elements into place using Weldbond, and then fill in the rest of the lid with tiles that fit. Here I have used some black and white manufactured tiles in addition to my own stamped tiles. Lastly, for a narrow strip that is left, you can use a grout stick from your stash to fill in the space. (See page 27.) Mark where the grout stick needs to be trimmed.

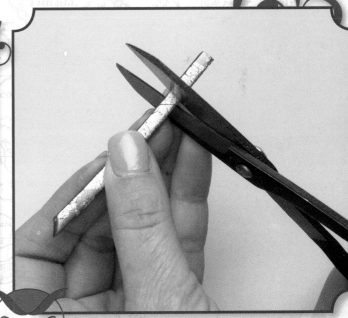

8 TRIM THE GROUT STICK

Trim the stick with tin snips to fit.

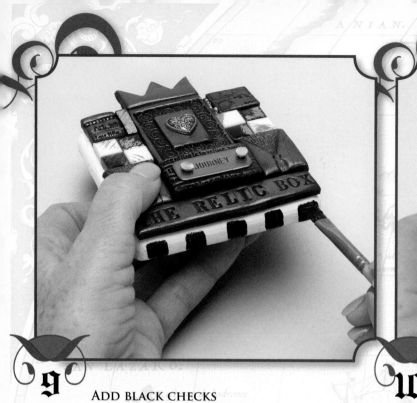

9 ADD BLACK CHECKS

Glue the grout stick in place. Any remaining gaps can be filled in the same way or with jewelry glue and seed beads. (See page 74). Paint black checks around the perimeter of the lid.

10 PAINT STRIPES ON LEGS

To paint stripes around the legs, hold the leg by the ball at the end, and rotate it as you hold the brush against the wood.

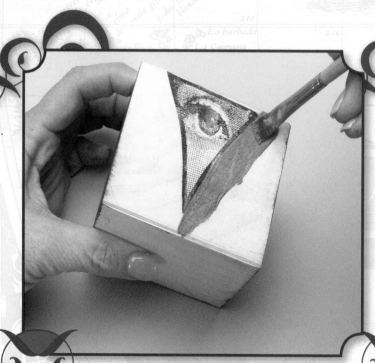

11 PAINT BOX

For the sides of the box, squeeze a bit of Quinacridone Gold, Raw Umber and black acrylic paints onto your paint palette. Paint some gold close to the stamped image.

12 RUB OFF EXCESS PAINT

Use a rag (or paper towel) to rub off the excess paint.

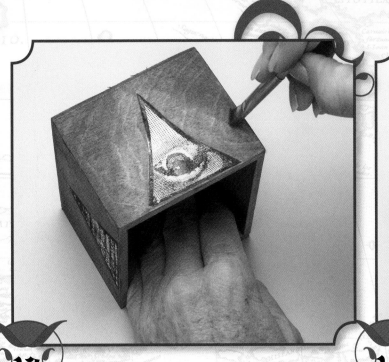

13 SHADE AROUND EDGES

Then mix equal parts of the gold and the Umber and just a teensy bit of black, and feather the paint from the edges of the box inward.

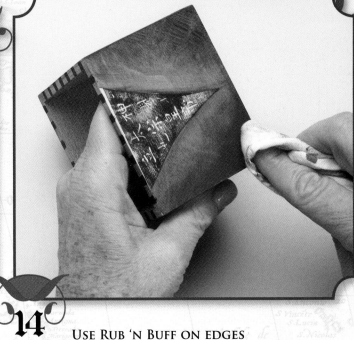

14 USE RUB 'N BUFF ON EDGES

Paint black slashes around the top perimeter of the box. Use a rag to apply just a bit of copper Rub 'n Buff to the outer edges of the box. A little goes a long way.

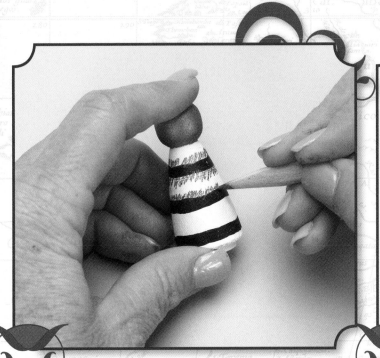

15 SCRIBBLE AROUND STRIPES

With a graphite pencil, lightly scribble lines where the black stripes meet the white paint. Do this on all four legs and also for the black-and-white checks around the lid. This softens the look.

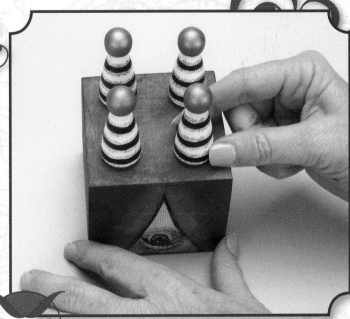

16 GLUE LEGS TO BOX

To glue the legs on the bottom of the box, set them in from the outside just a bit.

JEWEL BOX

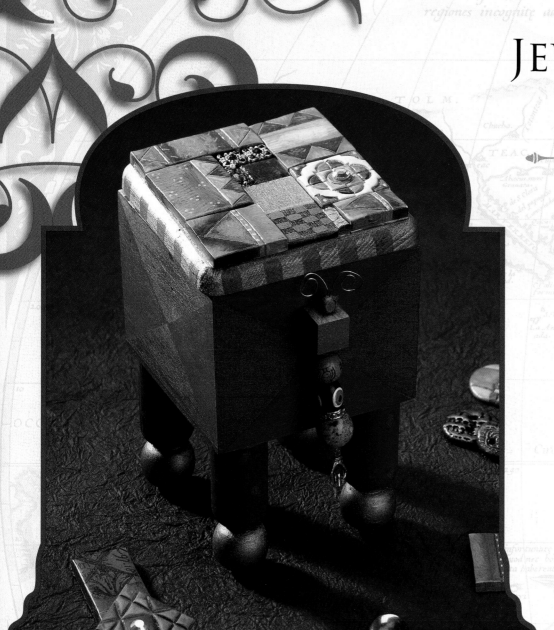

MATERIALS

wood box

legs

gold metallic spray paint

square wood beads

assortment of painted tiles

commercial tile

jewelry parts

rhinestones

seed beads

Weldbond glue

grout sticks

jewelry glue

assorted acrylic paints

various paint brushes

ruler

pencil

Weldbond glue

24-gauge wire

nippers

beads and charms for tassels

pliers

2 fishing weights

screwdriver

There are so many different looks that you can achieve by switching up the types of tiles you use to embellish the box top. Here, I've used all hand-painted tiles with jewelry pieces, which creates a very colorful and painterly look. It is fun to find jewelry and beads that enhance the colors on your box and create a sparkling jewel-like surface. This is the perfect box to hold a special necklace or bracelet.

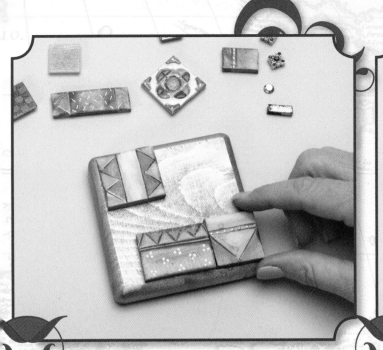

1 SPRAY PAINT BOX AND LAY OUT TILES

Spray the interior of your box with gold metallic spray paint.
Also paint two square wood beads and the box lid at the same
time. Leave one side of each bead (a side without a hole)
unpainted. Let all pieces dry.

To begin composing your tile design, gather your collection
of hand-painted tiles and place a few larger ones on the lid,
around the outside.

2 CREATE SMALL CHANNELS

Then begin trying out tiles to see which ones will fill in the spaces
between the larger tiles. This composition works pretty well.
Notice the space left in the lower center. It's too small for any tiles
that I currently have, so I will fill that space in a moment, with
some seed beads.

3 ADHERE GLASS TILE

When working with glass tiles, the grooved side goes at the
bottom. The grooves provide better adhesion, or, as I like to say,
"gription." Secure the tiles with Weldbond.

4 FILL UP WELL WITH GLUE

When gluing pieces of jewelry, be sure to apply a lot of glue to
fill in the well on the bottom of the jewelry piece.

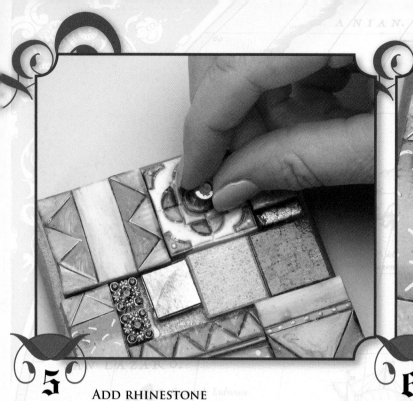

5 ADD RHINESTONE

Decide if you would like a rhinestone in the center of any of the tiles, and adhere it with jewelry glue.

6 FILL CHANNEL WITH GLUE

Finally, to fill in areas with seed beads (an alternative to grout), first use a jewelry glue with a long nozzle to squeeze the glue into the channels or gaps between tiles.

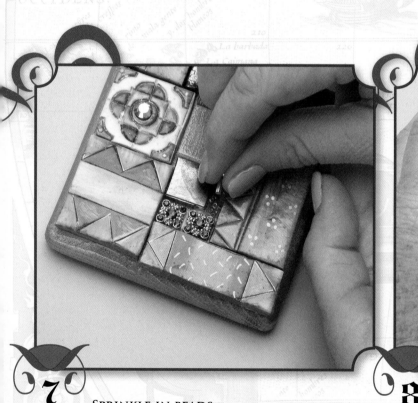

7 SPRINKLE IN BEADS

Sprinkle seed beads into your hands, and then sprinkle some beads over the glue. If, as the glue dries, the level of beads shrinks down too much, simply apply a second layer of glue and beads over the first.

8 PAINT BASE COLOR

Next, decide on the color you wish to paint the box so that it matches the colors on the lid. Give the entire outside of the box a base coat.

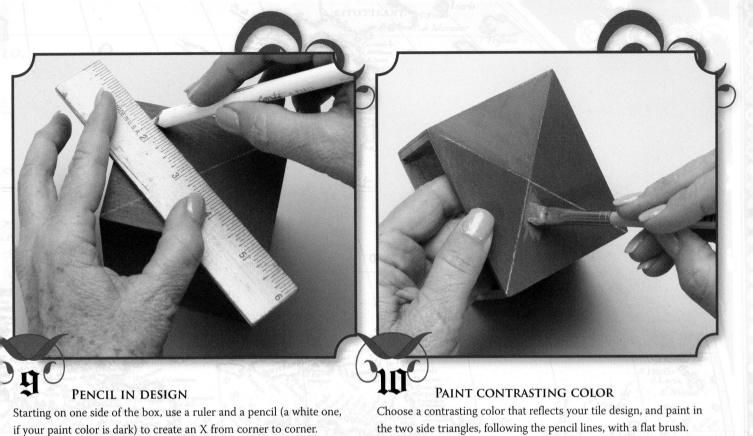

9 PENCIL IN DESIGN

Starting on one side of the box, use a ruler and a pencil (a white one, if your paint color is dark) to create an X from corner to corner.

10 PAINT CONTRASTING COLOR

Choose a contrasting color that reflects your tile design, and paint in the two side triangles, following the pencil lines, with a flat brush.

11 PAINT CHECKS AROUND THE LID

In the same color, paint little checks around the perimeter of the lid.

12 ADD SLASHES OF COLOR

Then add similar slashes of color around the top perimeter of the box.

13 PAINT LEGS

Paint the four legs for the box the same base color as the box, and then paint the balls of the legs gold.

14 ADD SLASHES OF COLOR

To finish the legs, add slashes of color over the base color, as you did for the perimeter of the lid.

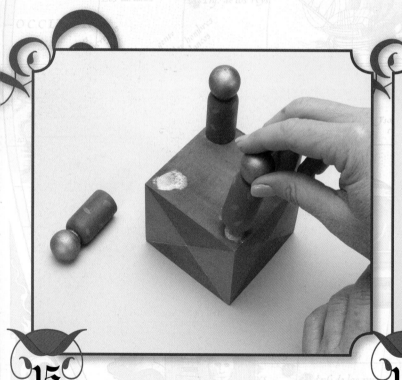

15 GLUE ON LEGS

Use your finger to dab a bit of glue in each of the four corners of the bottom of the box. Then place a second dab of glue on the bottom of each of the four legs, and adhere them to the box bottom.

16 ADD CHARM TO WIRE

To create tassels for the sides of the box, gather the two square beads that you painted in step 1, as well as 24-gauge wire and glass beads. Snip off a 10" (25cm) piece of wire and bend it in half. Thread a charm or bead on the bottom and let it hang in the bend of the wire.

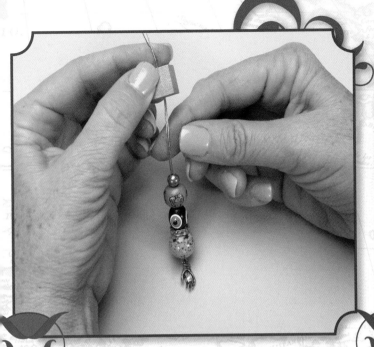

17 STRING ON BEADS

Twist the wire together and then thread on four or five beads. Then thread on one of the gold cubes.

18 CRIMP WEIGHT

Open up a fishing weight with a screwdriver. Pull the wire taut, and then crimp the weight over the wire, at the top of the cube to hold it in place.

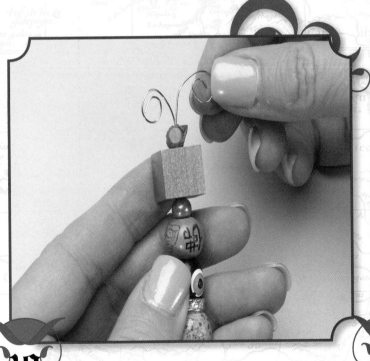

19 CURL WIRE ENDS

With pliers, curl the ends of the wire to give it a finished look.

20 GLUE ON TASSEL

Repeat steps 16–20 for the second tassel. With the box laying on its side, glue one of the tassels to the side of the box, positioning it just above the center, gluing the side of the square bead that is unpainted. Again, dab glue on both the box and the cube. When it has dried, turn the box over to the opposite side to glue on the other tassel, raising the box up on two blocks or rubber stamps to accommodate the first tassel.

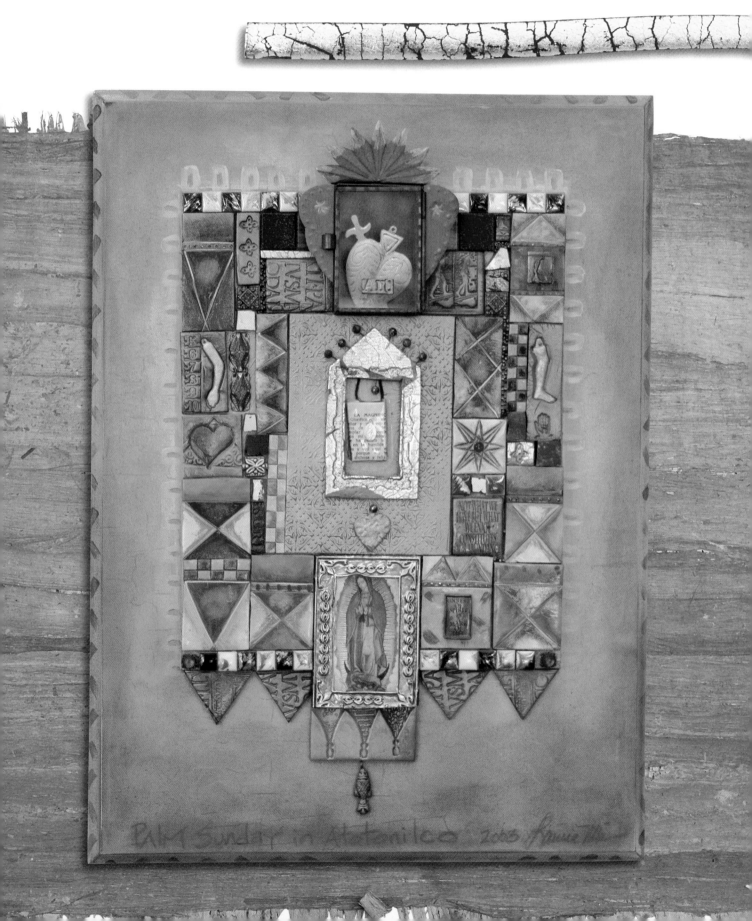

ATOTONILCO

A few years back, I traveled to the magical town of San Miguel de Allende in Mexico. It was the week leading up to Palm Sunday, a very special time for Mexicans in this predominantly Catholic country. There were wonderful processions and celebrations in town. The Friday night preceding Palm Sunday is called *Viernes de Dolores* or "Our Lady of Sorrows," better known in San Miguel as "Night of Altars." Many of the residents in town created altars with fruit, flowers (marigolds), incense and candles in their homes. These household altars were placed in areas where they were visible to passersby. These residents generously handed out fruit drinks and ice cream to those of us who strolled by.

The culmination of week-long celebrations led up to Palm Sunday, and on this day we were fortunate enough to take a trip to the Shrine at Atotonilco, about seven miles from San Miguel de Allende. Atotonilco, meaning "place of hot waters," is near a bubbling hot springs where the waters are said to be very curative. Up to 100,000 people make pilgrimages to this venerated church each year. It is a sacred site that is listed on the World Monuments Fund as one of the hundred most endangered monuments.

Almost the entire church is adorned with some of the most incredible, yet somber, frescoes. The Shrine at Atotonilco has been referred to as the "Sistine Chapel of the Americas," and it is easy to see why. On Palm Sunday, the market was in full swing leading up to where the shrine is located. Both sides of the dusty road had vendors elbow to elbow selling all types of religious items, including milagros, amulets and framed pictures of saints. Though I am not religious, I love the rituals associated with the religions of the world, and I was truly fascinated by the history of this church as well as the wares that the vendors were selling.

Many of the items included in this icon were purchased at the market on Palm Sunday, and for me this piece is a reminder of a very special time and place. I bought the tin nicho in San Miguel; it holds a large milagro heart. Farther down on the piece is a frame that holds a tiny tribute to a saint. At the bottom of the icon is the framed image of the Virgin of Guadalupe, one of the most sacred images for Mexican Catholics.

Because I am not very good at keeping a diary or a journal, "Palm Sunday in Atotonilco" is the most accurate record I have of my trip to San Miguel. This icon is an example of how you can collect special and significant objects while traveling to create a piece of art that will be a life-long keepsake of your journey.

TONIA'S BOX

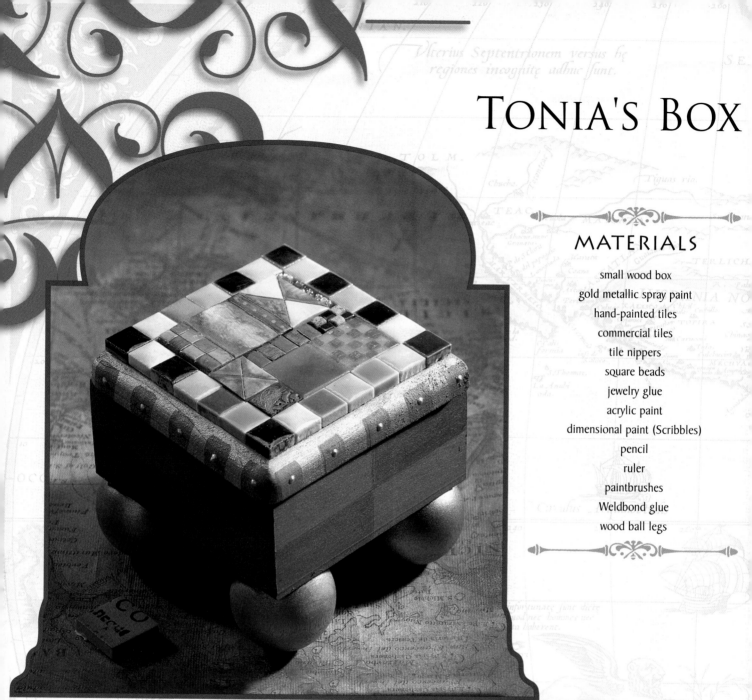

MATERIALS

small wood box
gold metallic spray paint
hand-painted tiles
commercial tiles
tile nippers
square beads
jewelry glue
acrylic paint
dimensional paint (Scribbles)
pencil
ruler
paintbrushes
Weldbond glue
wood ball legs

I love borders and have found another creative idea is to form a glass tile border around the edge of your box that can then be filled in with your hand-painted tiles. There is something about borders that is really appealing, and in many cases the border tile is as important to the whole composition as the center or focal point. There are so many options for creating tile borders because you can continue to place one border within another using different size tiles or even beads.

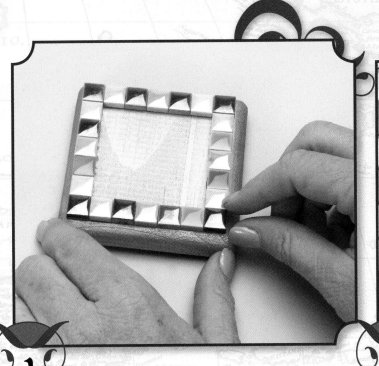

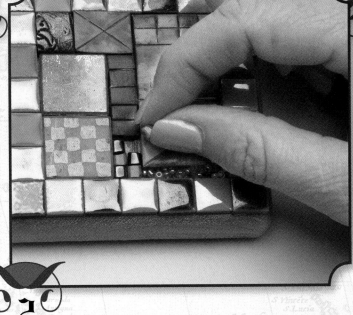

1 CREATE BORDER

Spray paint the interior of the box and the entire lid gold. Lay small commercial tiles around the top perimeter of the box, and then glue in place.

2 LAY OUT DESIGN AND FILL IN GAPS

Choose tiles to fill in the area inside the tiled border. When working within the confines of a small, established space, you may find you need to trim some of your clay tiles, or snip glass tiles with a pair of nippers to get everything to fit. (See page 12.) Finally, to fill in a remaining gap, create a checker pattern with square beads. Apply a thin layer of jewelry glue, and then set in the beads.

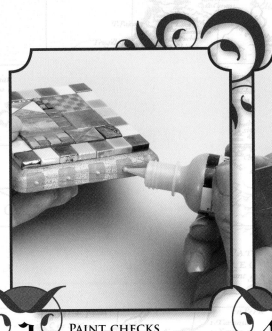

3 PAINT CHECKS AND DOTS

Paint checks of color around the perimeter of the lid. Then, using a Scribbles bottle, apply dots of paint in the center of each check.

4 PAINT A CHECKERBOARD

Paint the outside of the box in a base coat of color (here I used turquoise), and let dry. Then, using a pencil, draw a checkerboard pattern on each side with one horizontal line and one vertical line. Paint in the squares that are kitty-corner from one another with a contrasting color to create the checkered pattern.

5 GLUE ON LEGS

Continue painting the other sides of the box, and then paint the four ball feet gold. Glue the ball feet to the bottom of the box.

MIRACLE BOX

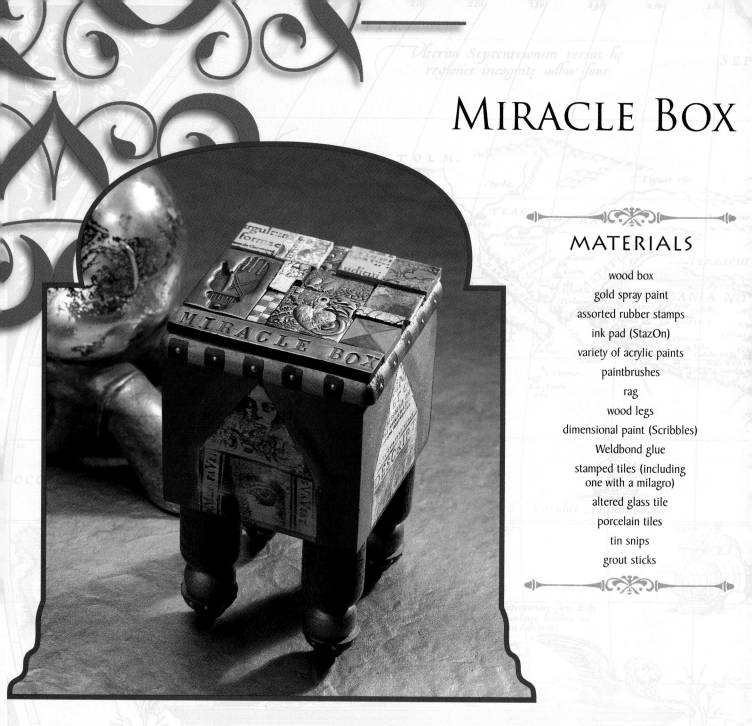

MATERIALS

wood box

gold spray paint

assorted rubber stamps

ink pad (StazOn)

variety of acrylic paints

paintbrushes

rag

wood legs

dimensional paint (Scribbles)

Weldbond glue

stamped tiles (including
one with a milagro)

altered glass tile

porcelain tiles

tin snips

grout sticks

The Miracle Box is another one of my favorite designs that I will often repeat as a theme. However, no two boxes are ever the same (as hard as you try to duplicate something, it never seems to work, but that's a good thing!). I always use a milagro on my Miracle Boxes to bring good fortune to their lucky owners!

I have to give credit to Carmen Schmitz, an artist in one of my classes, for teaching me the wonderful technique of rolling the legs across an inked rubber stamp. It creates such a cool look, especially if you use a text stamp.

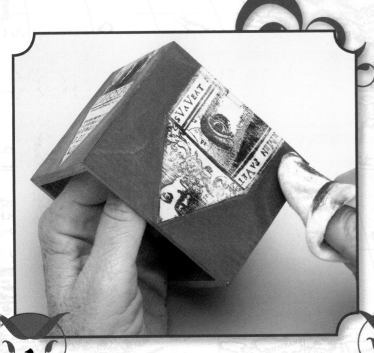

1 SPRAY, STAMP AND PAINT

Spray paint the interior of the box and the entire lid gold. Around the outside of the box, stamp a different house shape on each of the four sides. Paint around the stamped areas with a basecoat of color (here, purple). Gently rub off the excess paint with a rag.

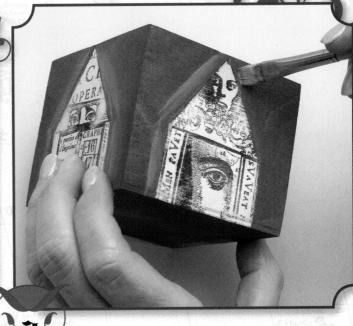

2 PAINT A SHADOW AROUND IMAGE

Using a fairly dry brush, use a painterly touch to add a bit of color around the outside of the stamped image, which creates a shadow effect.

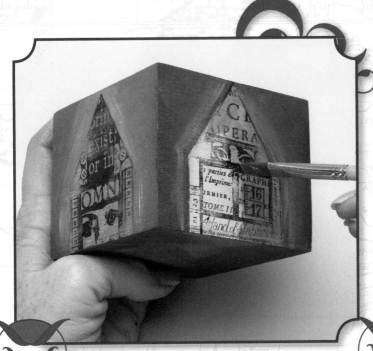

3 FILL IN WITH PAINT

Rub the color in with a rag. Paint over the stamped areas with a wash of Quinacridone Gold, and rub off the excess paint.

4 ROLL LEG OVER STAMP

Paint the main portion of the legs purple and the ball portion gold. Let dry. Ink up a text stamp with black StazOn ink, and then slowly roll the leg over the stamp. Repeat for the other three legs.

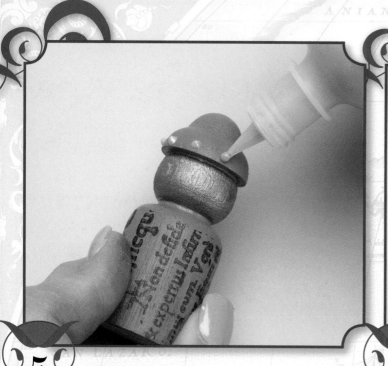

5 PAINT AND DOT CAP

Paint the cap portion of the legs periwinkle and let dry. Then add Scribbles dots around the perimeter.

6 ALTER PORCELAIN TILE

Apply a wash of color to a small sheet of manufactured porcelain tiles, and then stamp over the top to create several fragment tiles at once. (See page 14.) Here, I painted some of them with Quinacridone Gold to go with the sides of the box. Lay several of these tiles out on your lid and decide what other tiles you would like to fill in the rest of the lid's space. Then start gluing on the tiles.

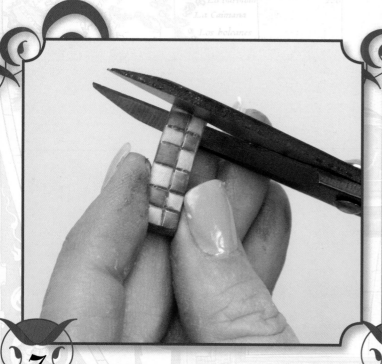

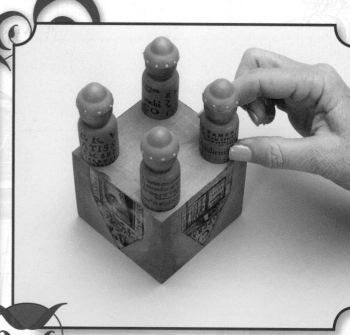

7 SNIP PAINTED TILE

For a final tiny space that is a bit too small for a clay tile, fill it with a painted tile that you cut with tin snips.

8 GLUE LEGS TO BOTTOM

Paint slashes of color and add dots around the perimeter of the lid. Finally, glue the legs to the bottom of the box.

FIESTA BOX

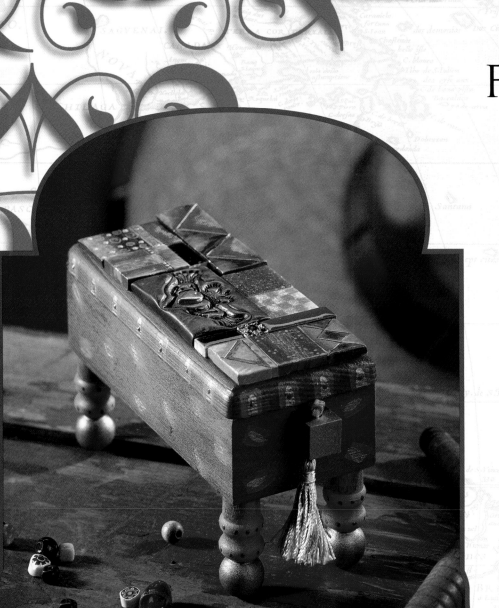

MATERIALS

oblong box
legs
2 square wood beads
gold spray paint
variety of acrylic paints
paintbrushes
dimensional paint (Scribbles)
gold gel pen
Weldbond glue
painted tiles
stamped tiles
commercial tiles
seed beads
jewelry parts
pre-made tassels
24-gauge wire
pliers

Sometimes it is important to think about function as well as beauty. You can find boxes in a variety of shapes and sizes, some better suited to contain specific objects. The Fiesta Box, with its oblong shape, is perfect to hold a necklace. Be mindful when you are shopping for boxes that you don't use a hinged lid. I did this once! The problem is that the top becomes too heavy with the mosaic tiles, and it will just topple over when you open it. Live and learn.

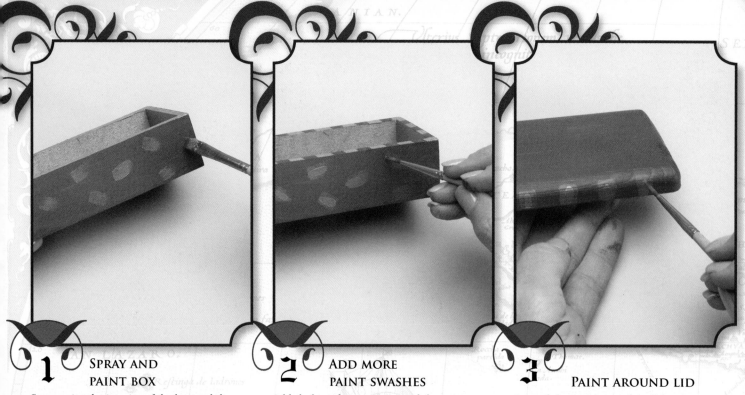

1 SPRAY AND PAINT BOX

Spray paint the interior of the box and the bottom of the lid gold. Also spray paint the two wood beads. Paint the top of the lid and the outside of the box magenta. When the box is dry, randomly add slashes of a contrasting color to all sides of the box.

2 ADD MORE PAINT SWASHES

Add slashes of magenta around the top perimeter of the box, and let dry. Next, go back over the slashes on the sides of the box with gold paint, using a detail brush.

3 PAINT AROUND LID

Around the perimeter of the lid, paint contrasting color checks. Then make a gold slash mark on each initial check, using a detail brush.

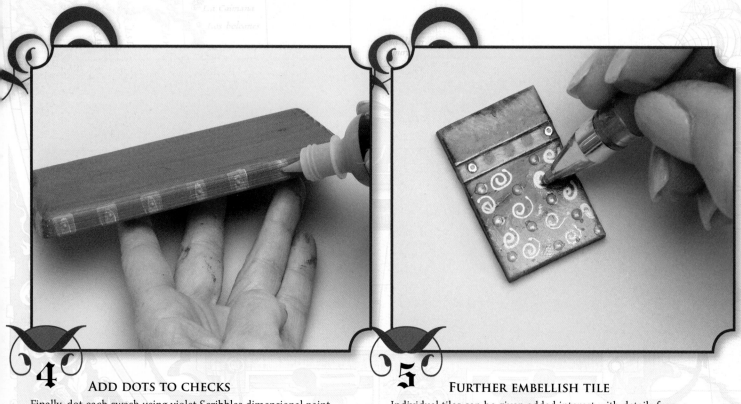

4 ADD DOTS TO CHECKS

Finally, dot each swash using violet Scribbles dimensional paint.

5 FURTHER EMBELLISH TILE

Individual tiles can be given added interest with details from a metallic gel pen, such as these swirls.

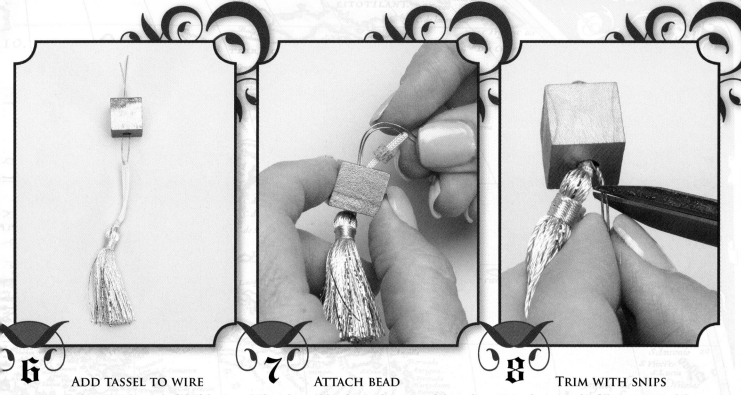

6 ADD TASSEL TO WIRE

Plot out and glue your tiles to the lid of the box. Set the lid aside and gather the two gold square beads and the two tassels. Cut a piece of wire to about 6" (15cm) and fold it in half. Thread the tassel onto the folded wire, and then use that to thread the tassel cord through the wood bead.

7 ATTACH BEAD

Thread a seed bead onto the wire and through the tassel cord. Then, thread both ends of the wire back through the gold wood bead.

8 TRIM WITH SNIPS

Twist the two ends of the wire around the tassel, and trim with metal snips. Repeat steps 6–8 to make another tassel.

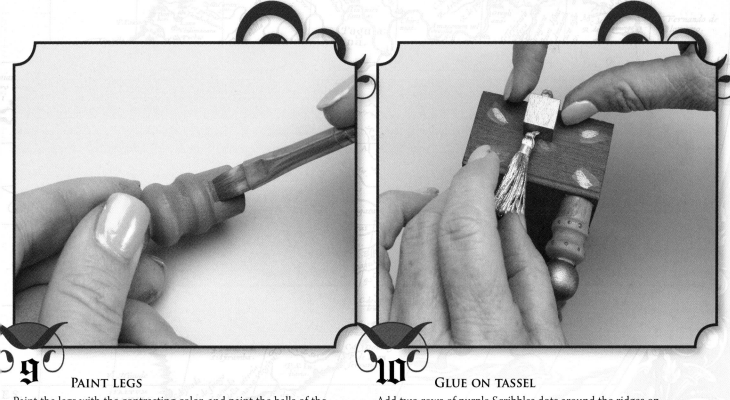

9 PAINT LEGS

Paint the legs with the contrasting color, and paint the balls of the legs gold. Add a wash of purple at the base of each leg.

10 GLUE ON TASSEL

Add two rows of purple Scribbles dots around the ridges on the legs. Then glue the legs to the bottom of the box. Finally, glue the tassels to the sides of the box.

TOLERANCE

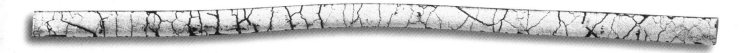

"Tolerance" is an icon I created in the aftermath of September 11, 2001. Like most artists, I find that art has the power to heal. In creating this mosaic, I was better able to come to terms with the way our world changed on that day.

On a trip to France the following year, I rummaged through a flea market in Provence and came across a bag of stamps from countries around the world. This became the catalyst for the mosaic "Tolerance." When I returned home, I began creating this political antiwar piece, which in fact became my first icon that used text. It opened the floodgates for all of the pieces that followed, as I realized that in using both text and imagery, I had found a perfect vehicle for self-expression.

This mosaic contains religious symbols that represent the world's major religions. I was hoping to create a piece of art that demonstrates respect for all religions and tolerance for the beliefs of people around the globe. It is only through the understanding that all religions and cultures are equally important to the people who follow them that we may avoid future clashes and wars. The white dove, a symbol of peace, is the focal point, surrounded by a border of stamps representing many nations. The framed saying, "War is not healthy for children or other living things," is on a notecard that my grandmother, who was as antiwar activist in the 1960s, gave to me about thirty-five years ago.

Having been fortunate enough to have traveled to the far corners of the world has expanded my capacity for tolerance and has given me a more global view. While peace is a lofty goal, especially in these very troubled times, it is nonetheless a goal worth striving for. "Tolerance" is an icon that demonstrates how political or philosophical ideas can be expressed in a mosaic and how healing art can be.

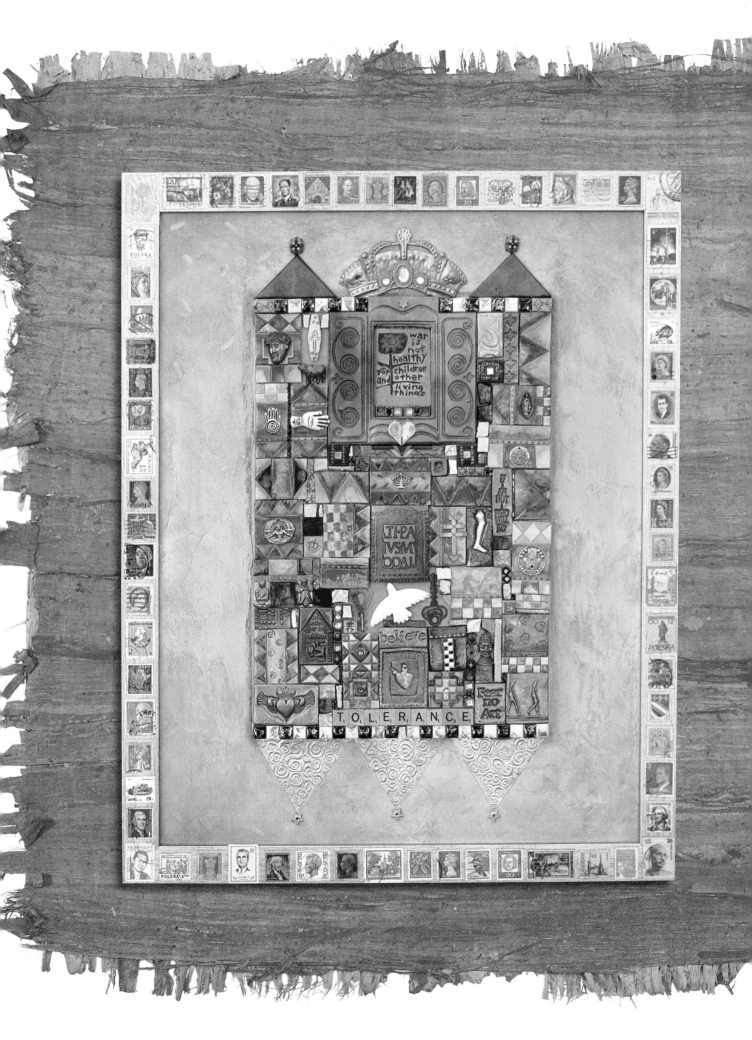

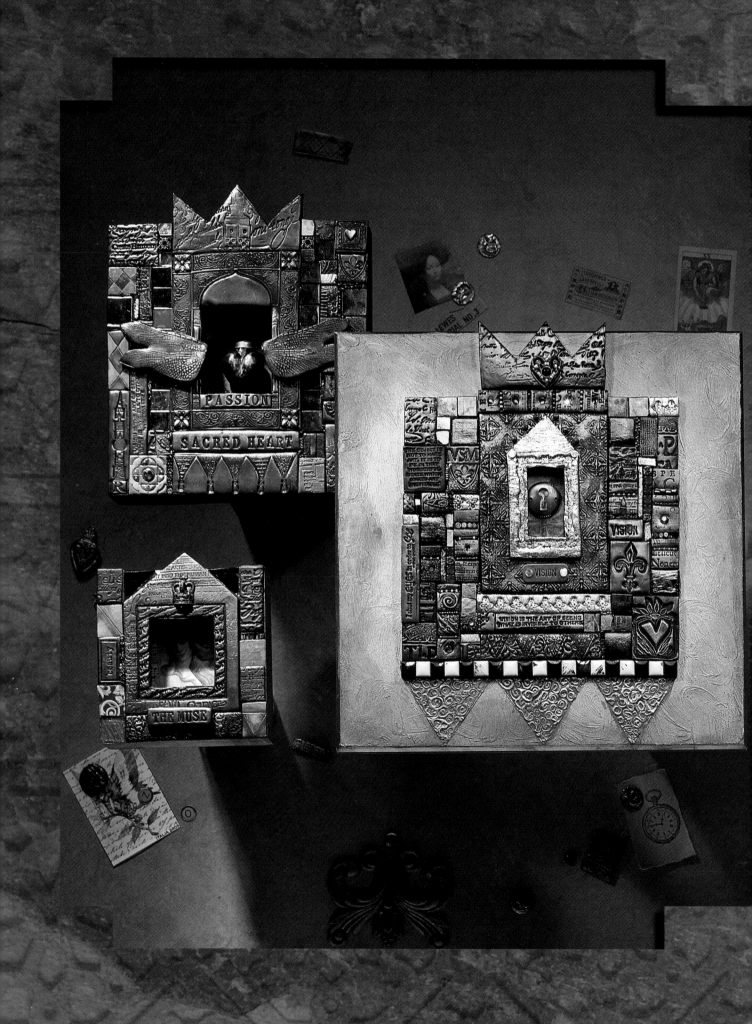

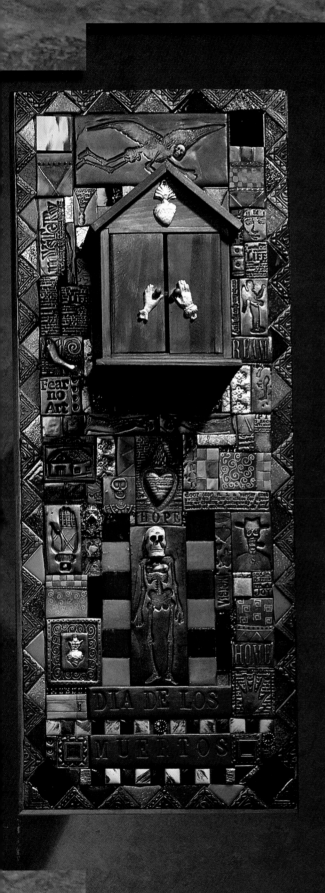

MOSAICONS

OF ALL THE ARTWORK THAT I AM CURRENTLY DOING, CREATING ICONS IS WHAT I AM THE MOST PASSIONATE ABOUT. THE REASON IS SIMPLE: I AM ABLE TO USE THIS FORMAT AS A MEANS OF SELF-EXPRESSION. I WASN'T QUITE SURE WHAT TO CALL THESE PIECES WHEN THEY FIRST EVOLVED. I DIDN'T LIKE THE TERM *WALL PLAQUE* BUT THEY DIDN'T REALLY FIT ANY OTHER CATEGORY SO I CAME UP WITH THE TERM *MOSAICONS*, WHICH IS A WORD THAT DESCRIBES MY MOSAIC ICONS. WHILE TRADITIONALLY AN ICON IS AN IMAGE OR REPRESENTATION OF A SACRED CHRISTIAN PERSONAGE, MY ICONS ARE SECULAR IN NATURE. AGAIN, THE ART OF THE MEDIEVAL AND BYZANTINE PERIODS IS AN IMPORTANT INFLUENCE IN MY OWN WORK. WHILE I AM NOT RELIGIOUS, I AM DRAWN TO THE WAY THAT ARTISTS DURING THESE TIME PERIODS USED ORNATE SURFACE DESIGNS TO CREATE ENDURING SYMBOLS OF THEIR FAITH. I LOVE THE FLATNESS, THE GOLD LEAF, THE RICH COLORS AND THE ATTENTION TO DETAIL OF TRADITIONAL ICONS. I ALSO APPRECIATE THEIR CAPACITY FOR STORYTELLING AND THEIR INHERENT SYMBOLISM.

I THINK THAT YOU WILL FIND CREATING ICONS, SUCH AS THE ONES SHOWN IN THIS CHAPTER, IS THE PERFECT WAY TO EXPAND ON YOUR OWN PERSONAL VISION. IT IS MY HOPE THAT YOU TAKE A LITTLE OF WHAT YOU LEARN IN THESE PAGES AND RUN WITH IT, CREATING ICONS USING YOUR OWN VOICE, TELLING YOUR OWN STORIES.

THE MUSE

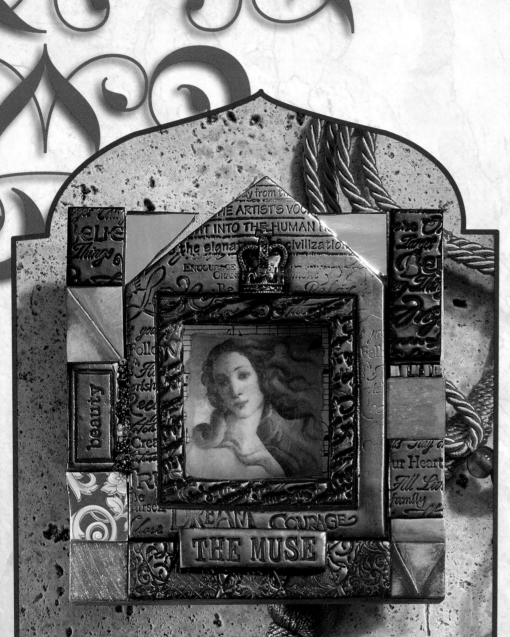

MATERIALS

small shadowbox frame

saw tooth hanger

hammer and nail

gold spray paint

collage papers

pencil

scissors

gel medium

distress ink

hand-stamped tiles

commercial tiles

wheel tile nippers

concrete patch

Weldbond glue

rag

Going to a gallery or a museum and seeing wonderful works of art is just the thing needed to spark an idea. Finding your muse, or source of inspiration, is a lifelong quest. Oftentimes it is found in the most unlikely of places, but reveling in the art of the great masters is a good place to start! For this icon, "The Muse", I have used a smaller shadowbox frame and began with a collage that I created from Botticelli's *Birth of Venus*.

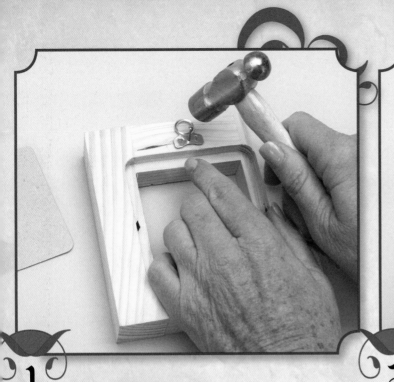

1 ADD HANGER TO BACK

Remove the cardboard insert from the unfinished shadowbox frame. Hammer in the hanger.

2 MEASURE FOR COLLAGE

Spray paint the entire frame with gold spray paint, and set it aside. Trim a piece of background paper to fit the cardboard insert. Here, I am using some decorative music paper. Set the frame over the cardboard to make it easy to position your focal image. Mark the spot with a pencil.

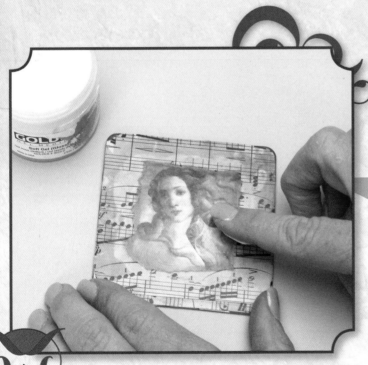

3 RUB IN INK

Using a rag, rub distress ink around the torn perimeter of the image to soften it a bit. Adhere the image with gel medium. Add more ink around the image over the background, and then brush additional gel medium over the entire piece.

TILE TIP

Concrete patch works well to adhere three-dimensional objects and is good for adhering something to an uneven surface.

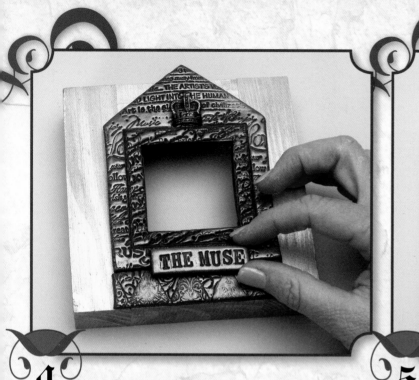

4 LAY OUT LARGER PIECES

Set the collaged piece aside. Create a house frame that will fit over the opening in your shadowbox. (See page 36.) Also create a separate piece that will fit below the house, as well as a title tile. Glue these primary pieces on the frame first, using Weldbond.

5 CUT TILE FOR ROOFLINE

For the triangular pieces that are left on either side of the roof shape, a tile that has been directly cut in half diagonally works well.

TILE TIP

In this project, it was the image that inspired the whole piece, so I started with the collage insert, but sometimes it's better to create the mosaic portion first and then find an appropriate image to put in the frame.

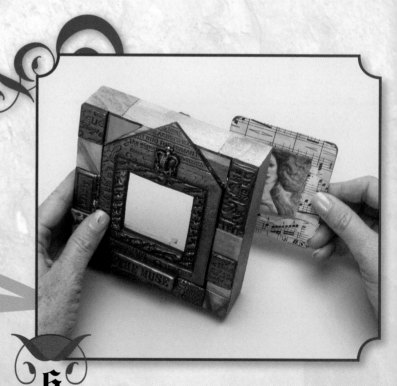

6 PLACE COLLAGE INTO FRAME

Figure out the remaining tiles and placement, glue in place and insert your collage to finish.

SACRED HEART

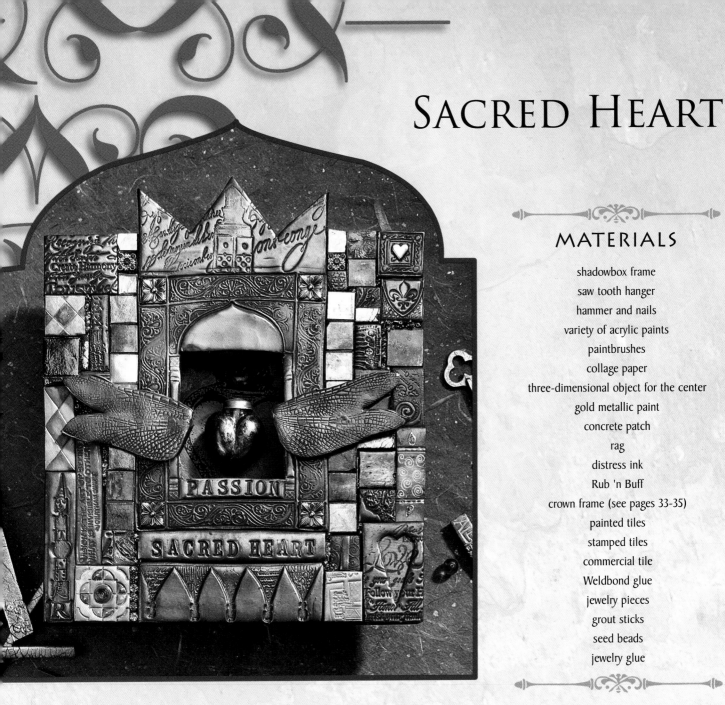

MATERIALS

shadowbox frame

saw tooth hanger

hammer and nails

variety of acrylic paints

paintbrushes

collage paper

three-dimensional object for the center

gold metallic paint

concrete patch

rag

distress ink

Rub 'n Buff

crown frame (see pages 33-35)

painted tiles

stamped tiles

commercial tile

Weldbond glue

jewelry pieces

grout sticks

seed beads

jewelry glue

I love finding inspiration when I'm not looking for it. Such was the case with the "Sacred Heart" icon. I happened to have bought some wrapping paper from a store that sells Mexican folk art to wrap a wedding present. The wrapping paper had a beautiful turquoise background and was stamped with large cobalt blue milagro hearts. Weeks later, I happened to be looking through my stash of paper when I spied my previous find, and I knew instantly that it would make a great background for one of my icons.

"Sacred Heart" was created using a shadowbox frame. I like the recessed area to create a focal point, in this case the turquoise paper with a bright red glass heart—the sacred heart—in the center. This icon incorporates both hand-painted and hand-stamped tiles along with commercial tiles and jewelry parts to create a truly mixed-media mosaic.

1 PAINT SHADOWBOX

Remove the cardboard insert from the frame and set aside. Mix paint colors that will coordinate with the majority of the tiles that you'll be using. Apply a slightly watery coat, and then wipe off the excess. Cover the entire frame.

2 CREATE COLLAGE BACKGROUND

Hammer the hanger on the back, and then set the frame aside. Cover the cardboard insert with the paper of your choice. Here, I'm using wrapping paper. A bit of color can be added with acrylic paint, if you like.

3 DISTRESS OBJECT

Small glass ornaments work well inside these shadowboxes. I like to distress ones that are new with a bit of paint. Here, I am dabbing a bit of gold paint on with my finger.

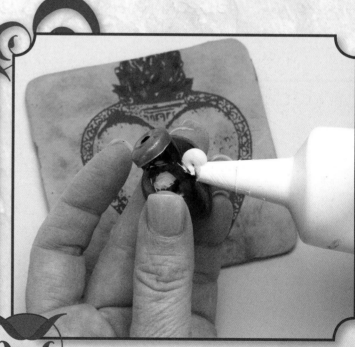

4 USE CONCRETE PATCH

Adhere the ornament to the collage with concrete patch.

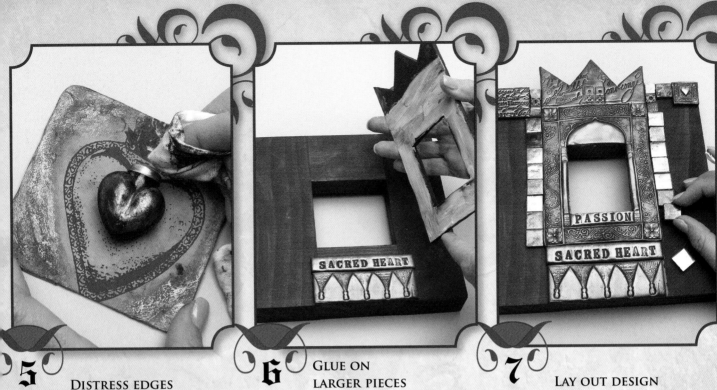

5 DISTRESS EDGES

Add any additional finishing touches such as distress ink around the edges and a little bit of metallic paint and metallic Rub 'n Buff on the ornament cap.

6 GLUE ON LARGER PIECES

Create a crown frame and separate, coordinating tile to go below it (see pages 33–35.) Also create a title tile. Adhere these primary elements to the painted frame.

7 LAY OUT DESIGN

Begin laying out your remaining tiles to figure out the best placement. Here, I started in the top corners and worked my way to rows of manufactured tiles along both sides of the crown frame.

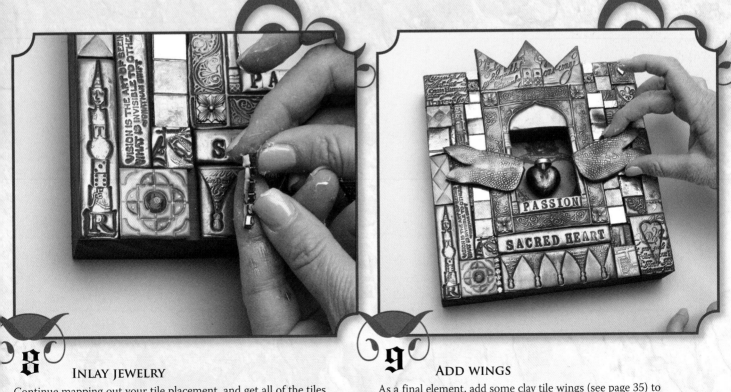

8 INLAY JEWELRY

Continue mapping out your tile placement, and get all of the tiles glued in place. Segments of a rhinestone bracelet work well for long, narrow spaces. The pieces may shift back and forth as you lay the segment down, but it's easy to adjust them, using a needle tool.

9 ADD WINGS

As a final element, add some clay tile wings (see page 35) to complete the sacred heart theme. The wings can extend over the opening a bit to add dimension.

The second time that I visited San Miguel de Allende in Mexico, I felt like a seasoned visitor there. I had to return after my first trip to show my husband, my sister and my brother-in-law the beauty that is San Miguel. The worn cobblestone streets and the beautiful patina of time are evident on every street. There is a saying that it is the "magic behind the doors." For everywhere throughout San Miguel, charming homes are hidden behind impressive facades, and when you open the door, you enter a portal where time seems to have stood still. The lush gardens and vibrant colors look like they have always been there since this colonial town was founded in the 1600s.

It is not only the colors and beauty that continually beckon me to Mexico; it is also the culture, the rites of passage and the celebrations of both life and death. One of the celebrations that I find most appealing is that of Dia de los Muertos, or "Day of the Dead." This is the holiday that occurs on November 1 and 2 and coincides with All Saint's Day. Dia de los Muertos is the day when the deceased are said to return home. Families decorate altars paying homage to their loved ones. The altars are comprised of their favorite foods, photos, music and drink. While this is a holiday that honors the dead, it is very much a celebration of life.

"Waiting for a Miracle" is an icon that was created with little trinkets and flea market finds from San Miguel, including milagros, which literally translated means "miracle." These little silver charms that come in a variety of shapes are based on traditional Latin American talismans. Milagros, which are thought to be magical, are used as a way for people to give thanks for a miracle or to ask for help for one. In the past, they were most often tacked onto churches to give thanks for answered prayers.

Dia de los Muertos is a holiday that I would love to see take place in North America. While we have Memorial Day and Veterans Day to honor those who have fallen serving this country, we don't have a day dedicated to really celebrate and honor the loved ones in our own families who have passed away. I think it is also a holiday that helps people come to grips with loss and grief, for their loved ones are never too far from their hearts. One only needs to wait for a miracle for their loved ones to return on Dia de los Muertos.

MIRACLE

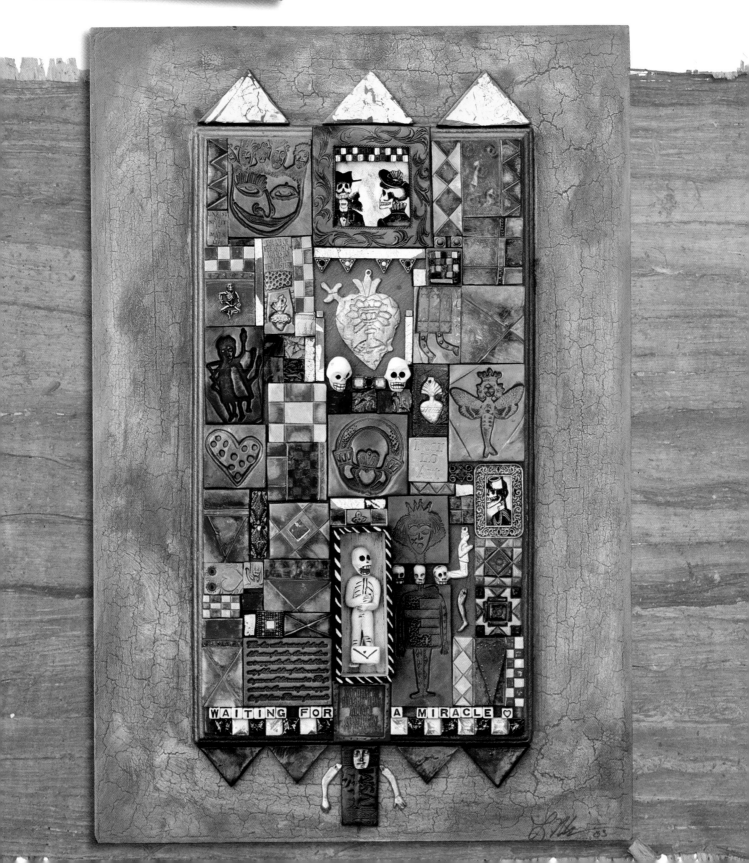

WAITING FOR A MIRACLE

VISION

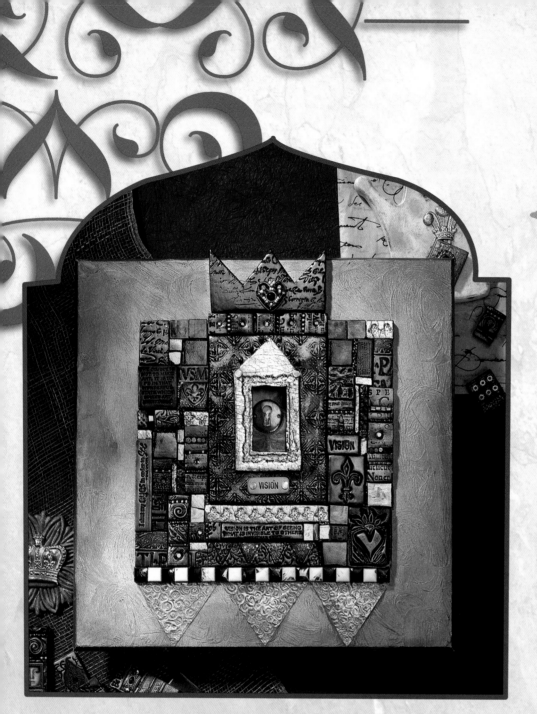

MATERIALS

wood backing

mastic

saw tooth hanger

hammer and nails

gold spray paint

ruler

pencil

commercial tile

gold foil

scissors

stylus

Silver Rub 'n Buff

acrylic paints

cardstock

collage pieces

keyhole charm

stamped frame

stamped tiles

beaded tiles

Weldbond glue

gel medium

grout sticks

jewelry glue

seed beads

jewelry pieces

Medieval art has been a huge source of inspiration as my work has evolved. I love the gold tones and the jewel-like surfaces. "Vision" is an icon that draws on this type of imagery with a limited palette of gold tones and earth colors. This icon, "Vision," began with the small collage with the keyhole in the center and the rest just flowed from that. To create a very ornate surface, I used many of the beaded tiles I have been playing with. These detailed beaded tiles, while time-consuming to make, create a look that is intricate and sparkly. You will notice that there are no hand-painted tiles in this piece, as I wanted to keep the colors muted.

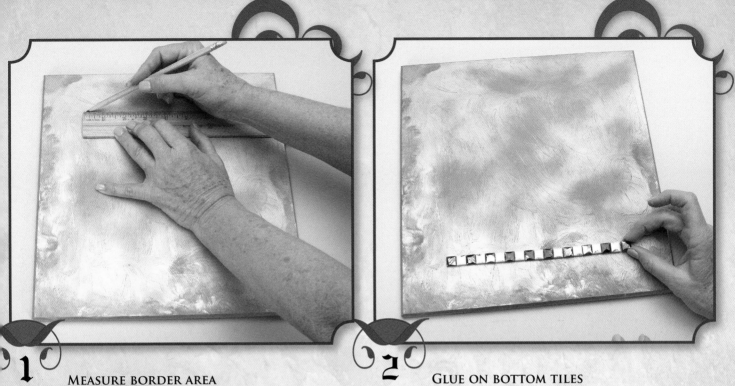

1 MEASURE BORDER AREA

Apply mastic or tile adhesive to your board and create a swirled pattern with the adhesive. (See page 11.) Let dry, then spray paint it gold. Attach a hanger to the back. Leaving about a 2" (5cm) border on all sides on the front, mark a line to indicate where the tiles will go.

2 GLUE ON BOTTOM TILES

Along the line at the bottom, glue alternating black and white commercial tiles.

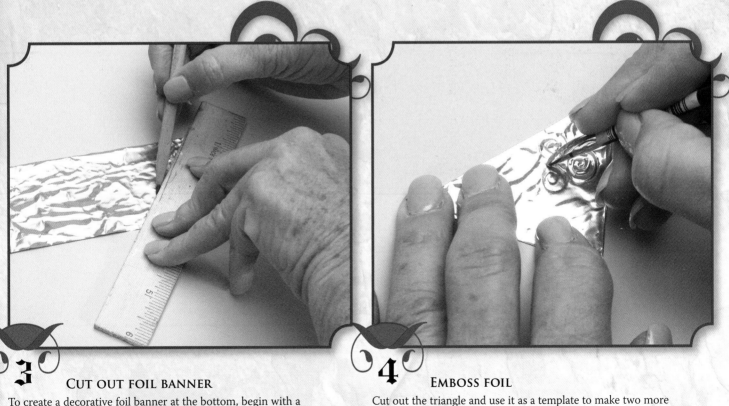

3 CUT OUT FOIL BANNER

To create a decorative foil banner at the bottom, begin with a length and width of foil that fits from the bottom of the tiles to the bottom of the plaque. Draw a 45-degree angle on one end of the foil, then a second line after it, to create a triangle shape.

4 EMBOSS FOIL

Cut out the triangle and use it as a template to make two more triangles. Using either a stylus or the end of a paintbrush, emboss spiral shapes on the silver side of the foil.

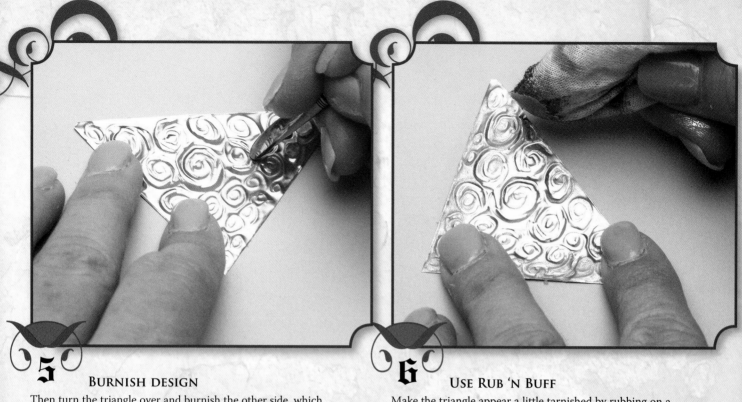

5 BURNISH DESIGN

Then turn the triangle over and burnish the other side, which helps add dimension.

6 USE RUB 'N BUFF

Make the triangle appear a little tarnished by rubbing on a mixture of silver Rub 'n Buff and Raw Umber paint.

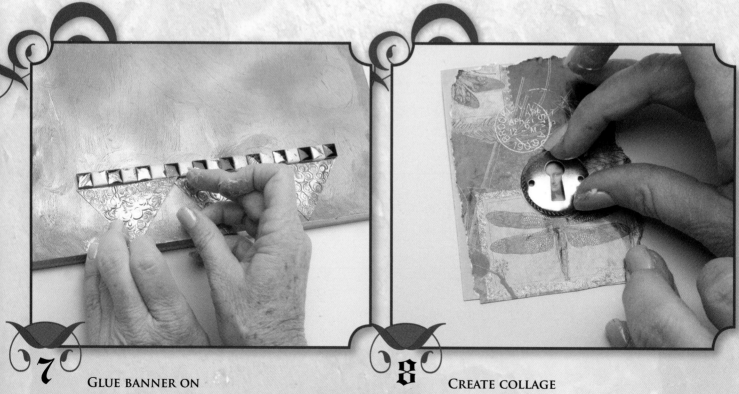

7 GLUE BANNER ON

Repeat for the other two triangles, and then adhere them to the bottom of the checked tile row using Weldbond.

8 CREATE COLLAGE

Glue a scrap of wrapping paper that you like to a piece of cardstock, such as an artist trading card, using gel medium.

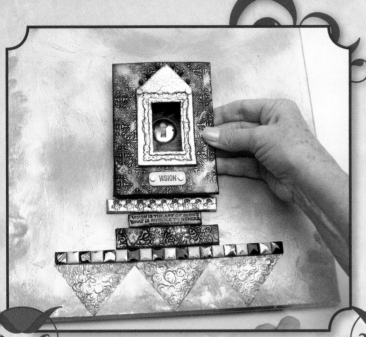

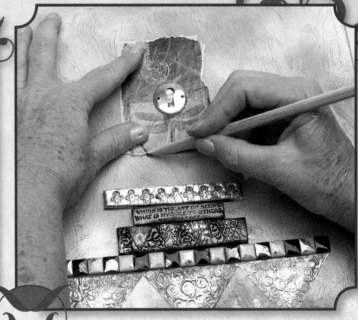

9 ADD A KEYHOLE

Place a face sticker on the wrapping paper. Then glue a keyhole charm over the sticker so that the face is peeking out. Use a liberal amount of Weldbond to adhere the charm.

10 LAY OUT DESIGN

Lay out the main elements on the plaque to give you placement for the collage.

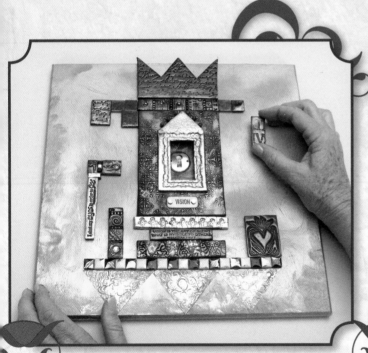

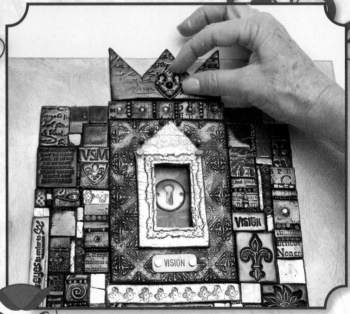

11 MARK FOR COLLAGE

Use a pencil to mark the exact placement of where the collage will go.

12 GLUE ON TILES AND ADD A JEWEL

Glue the collage to the board using Weldbond. Adhere the main tile elements with glue, then figure out the placement for the remaining tiles. After the tiles are glued down, add a "crown jewel" to finish.

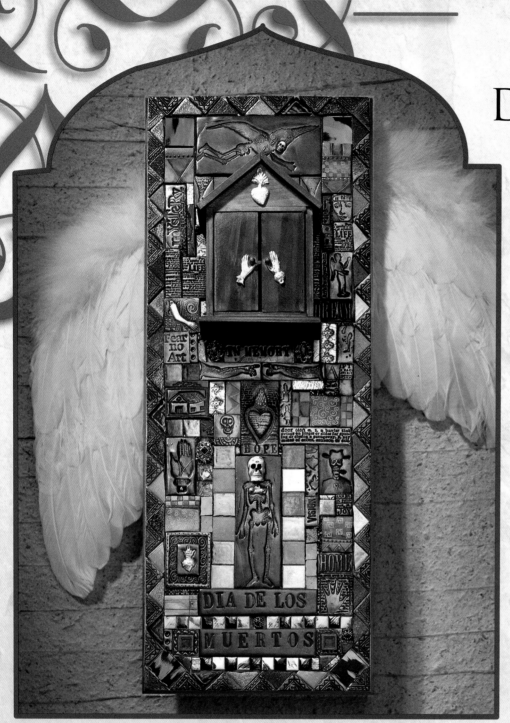

DIA DE LOS MUERTOS

MATERIALS

Premo! clay

rolling pin

wax paper

clay blade

assorted rubber stamps

mica powder

roasting pans

binder clips

tin snips

tile nippers

commercial tiles (including mirror)

mirrored tiles

rectangular board

saw tooth hanger

hammer and nails

mastic

gold spray paint

Weldbond glue

small wood doll house

variety of acrylic paints

paintbrushes

rags

milagros

stamped tiles

painted tiles

grout sticks

seed beads

jewelry glue

jewelry pieces

Dia de los Muertos is my favorite holiday that is celebrated in Mexico. Once a year I make an icon that celebrates the occasion using all types of skeletons, skulls and ephemera that I have collected on my trips to Mexico. This icon is combined with a three-dimensional shrine that projects off the surface to hold something special or sacred and that can be personalized to honor a loved one who has passed away. I have used a combination of both painted tiles and stamped tiles. I first started with a border that uses polymer clay tiles cut on the diagonal along with commercial tiles, also cut on the diagonal, which creates an interesting effect.

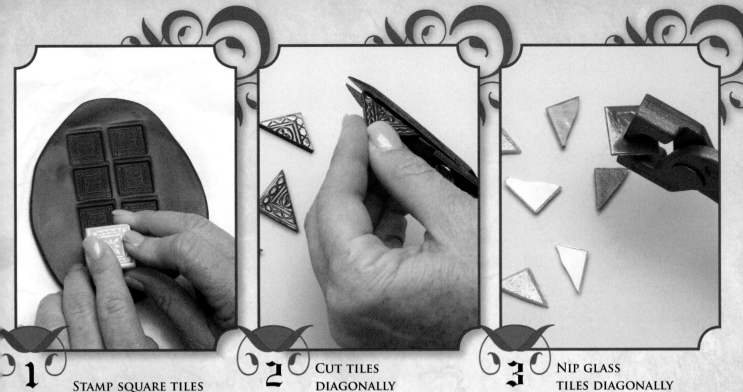

1 STAMP SQUARE TILES

There are numerous square stamps that work great for making square tiles. For this project, you will need about twenty-four 1" (3cm) stamped tiles. Condition and roll out the clay, and then stamp with a square stamp numerous times.

2 CUT TILES DIAGONALLY

Add mica powder to the tiles, and trim and bake as directed. Then cut each of the clay tiles diagonally in half.

3 NIP GLASS TILES DIAGONALLY

Gather about twenty-four manufactured tiles in various shades of blue, and use tile nippers to cut the tiles in half, diagonally.

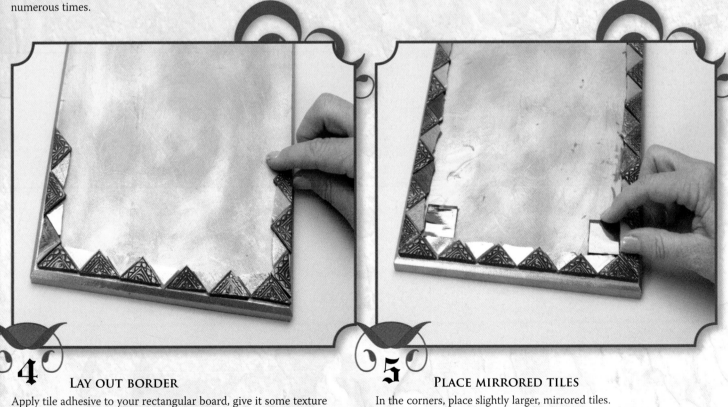

4 LAY OUT BORDER

Apply tile adhesive to your rectangular board, give it some texture and let it dry. Then spray paint it gold. When the paint is dry, begin gluing on your triangular tiles around the edge. The clay tiles have a cleaner, straighter edge, so I like to put them along the outside with the glass tiles alternating between them on the inside.

5 PLACE MIRRORED TILES

In the corners, place slightly larger, mirrored tiles.

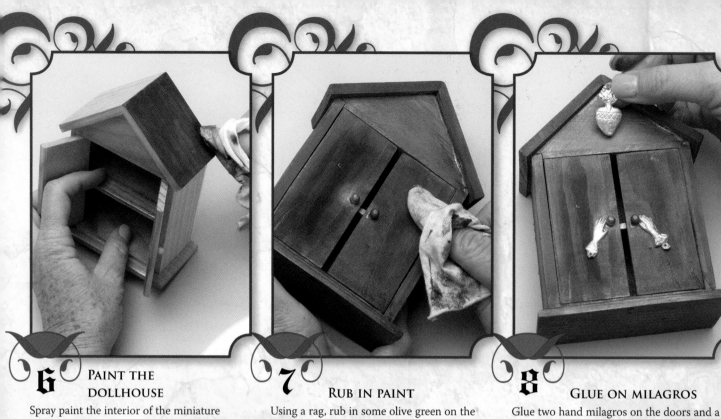

6 PAINT THE DOLLHOUSE

Spray paint the interior of the miniature house gold. To give the exterior of the house a slightly Raku feel, use a combination of equal parts of Silver Sterling, Violet Prism, Raw Umber and just a tiny bit of Mars Black. Mix everything together and apply a basecoat to the entire exterior.

7 RUB IN PAINT

Using a rag, rub in some olive green on the eaves and the roof, some copper along the edges and a little bit of the violet on the doors.

8 GLUE ON MILAGROS

Glue two hand milagros on the doors and a heart at the top in the center.

9 PLACE DOLLHOUSE SHRINE

Begin laying out the tiles that go up the center to give you a sense of where to glue your house.

10 ADD TILES TO SMALL AREAS

Finally, to fill in around the roof of the house, cut small clay tiles in half and adhere.

TIME HEALS

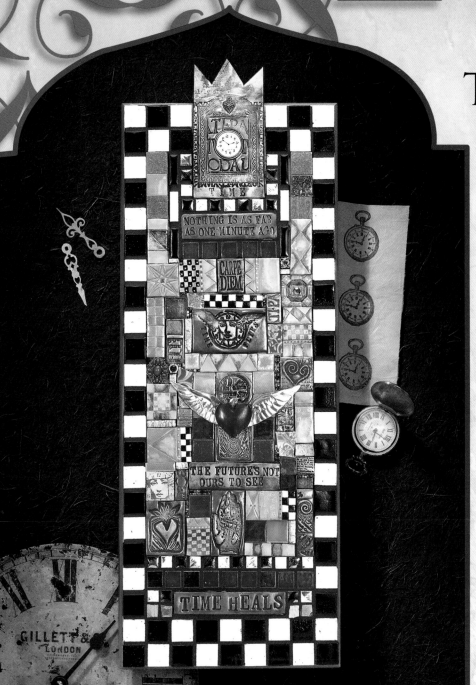

MATERIALS

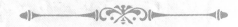

rectangular board

mastic

saw tooth hanger

hammer and nails

gold spray paint

commercial tile

square stamped tiles

stamped tiles

painted tiles

crown frame

painter's tape

black grout

latex or other disposable gloves

sponge

bucket

rags

Weldbond

jewelry pieces

charms

tin heart

pin

seed beads

jewelry glue

grout sticks

ime Heals" is an icon that combines a traditional grouted mosaic border with other areas that use seed beads as grout. I enjoy combining the two different approaches to mosaics, and I like how the grout looks when it's surrounded by polymer clay tiles. Grouting is a pretty messy business, but it can often enhance the overall look of a mosaic by unifying it. Conversely, there are times when grout would definitely take away from a piece by creating a pattern of grout joints that your eye focuses on instead of on your handmade tiles. I will show you some tips for protecting your polymer clay tiles when grouting.

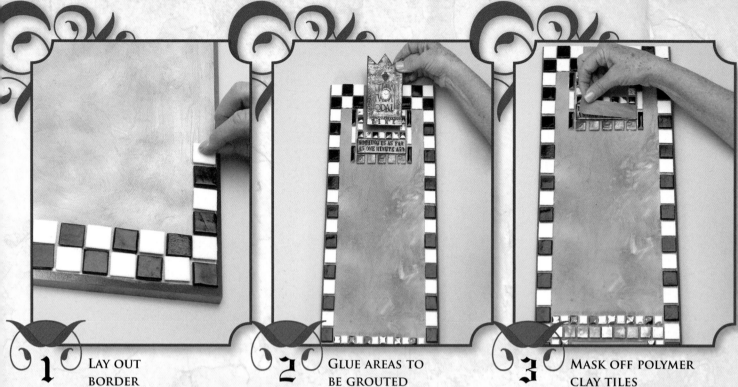

1 LAY OUT BORDER

On a piece of wood that has been prepped with mastic and spray painted gold, lay out black and white commercial tiles in two rows at the bottom, in a checkerboard design. Leave a tiny bit of space between the tiles for grouting. Continue alternating the tiles up both sides.

2 GLUE AREAS TO BE GROUTED

Glue down all of the tiles that you wish to grout, including a few polymer clay tiles. Make a space where the crown frame will go, but remove it before grouting.

3 MASK OFF POLYMER CLAY TILES

With painter's tape, mask off the tops of the polymer clay tiles so that the grout doesn't get into their grooves. This part can be tedious, so you may wish to limit the number of polymer clay tiles that receive grout.

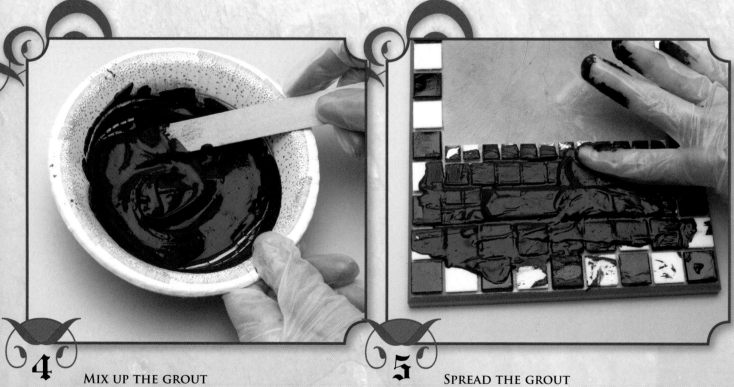

4 MIX UP THE GROUT

Mix up a small batch of black tile grout, according to the package directions. I like the consistency to be like pudding.

5 SPREAD THE GROUT

Wearing protective gloves, start spreading the grout over the areas that have tiles.

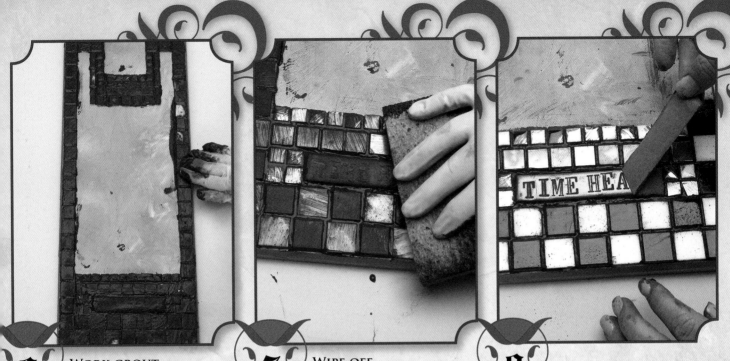

6 WORK GROUT INTO GROOVES

Work the grout into the grooves, both along the tops and the sides, but try to keep the grout away from the nontiled areas that are still gold. If you do get some on the board, just wipe it off. Also, make sure there are no clumps of grout along the sides of the tiles, or they might interfere with the tiles to be adhered later.

7 WIPE OFF EXCESS GROUT

Let the grout set until the shine has gone away, then begin wiping off the excess grout with a damp sponge. It's best to work next to a large bucket of water so that you can continually rinse out your sponge. Don't pour the grout water down your kitchen sink!

8 REMOVE TAPE

Continue gently wiping away the grout, and then polish the individual tiles with a rag to remove any leftover residue. When the grout has all been removed, gently peel off the painter's tape from the polymer clay tiles.

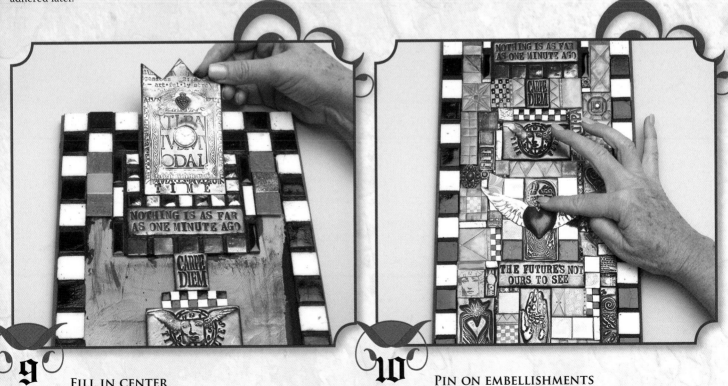

9 FILL IN CENTER

Now you can begin filling in the rest of the space with a mixture of clay tiles, commercial tiles and other goodies.

10 PIN ON EMBELLISHMENTS

Finally, if want you to add any charms or embellishments with a tack or a map pin, you can just push the pin directly into one of the clay tiles.

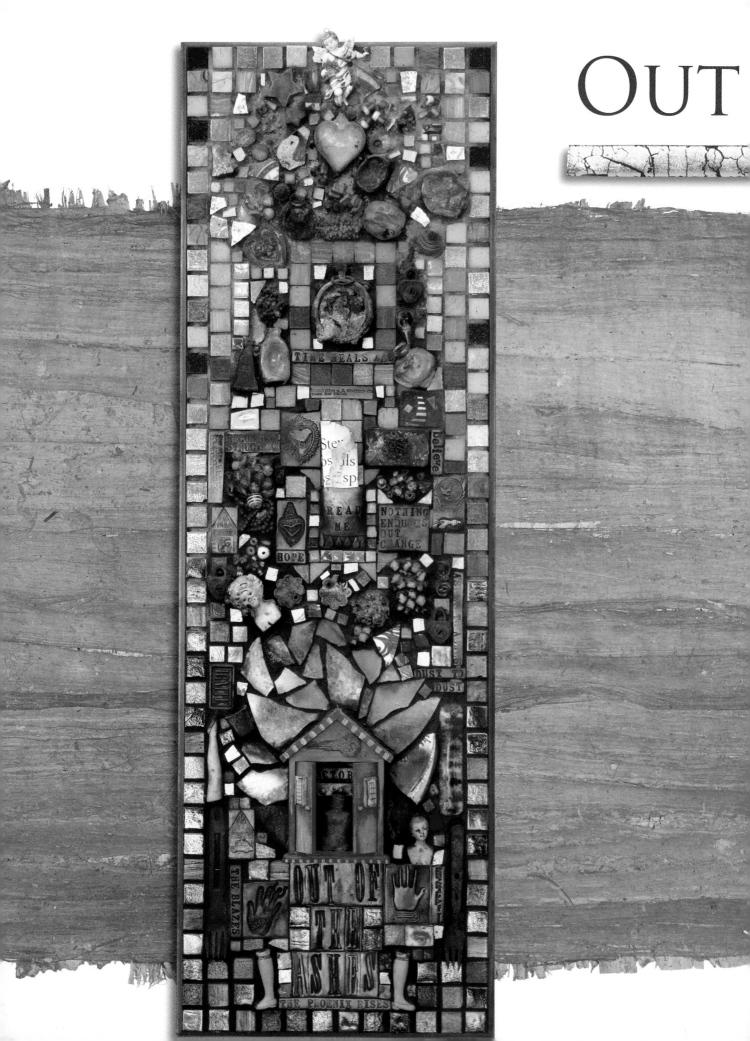

OF THE ASHES

In the fall of October 2003, wild fires, fueled by Santa Ana winds, ravaged a huge portion of San Diego County. In the early morning hours of October 26, we awoke to see the sky directly east of us filled with tremendous billows of black, gray and reddish smoke. We found out that the Cedar Fire, as it became known, was bearing down on the community of Scripps Ranch and devouring everything in its path.

We have good friends who live in Scripps Ranch on a beautiful lot with expansive and unhindered views to the canyons and hills beyond. We knew the moment we heard that Scripps Ranch was in the path of the fire that their home would be one of the most vulnerable. We called at 9:15 a.m. and left a message on their answering machine—and found out later that may have been the last message on their machine because it was estimated by fire officials that their home burned to the ground at approximately 9:30 AM. They lost everything, save for a few pieces of irreplaceable art and a couple of framed photos that they quickly threw in their car as they hurriedly evacuated the area.

Ten days later I was sifting through the rubble of what was once their home, seeking bits and pieces to incorporate into this mosaic, "Out of the Ashes." It was amazing to see the few remnants that miraculously remained, including a Hopi ceramic pot that was completely intact. I was able to scavenge fused beads, doll parts, a few ornaments, jewelry pieces, shards of glass and a couple of forks that had melted in what was the dishwasher. It is these pieces that came together to create the foundation of this mosaic.

This mosaic icon was designed to be a symbol of hope, rooted in the legend of the Phoenix. This fabled bird perished in its nest amidst flames sparked by the sun but was reborn anew. "Out of the ashes, the Phoenix rises," is a powerful symbol of rebirth and renewal and is the perfect theme for this mosaic. In this piece, I created the lower portion of the mosaic in darker colors with shards of glass flames surrounding a wood dollhouse. As the eye moves up the mosaic, the tiles become lighter. Rubbing ash into the grout created this effect. At the top of the mosaic is an angel (one of the few remaining holiday ornaments found among the debris) symbolizing hope and renewal.

Using the format of mixed-media mosaics, the shards and household remains are easily juxtaposed next to new tile and personalized stamped tiles. "Out of the Ashes" is an icon that shows how using found and discarded objects as well as debris from a tragedy such as this can be transformed into a meaningful piece of art.

GALLERY

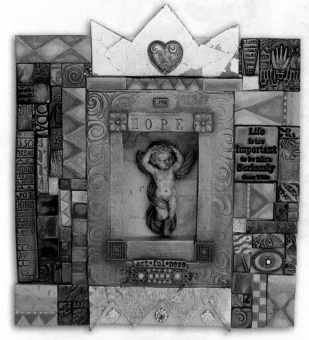

ANGEL OF HOPE

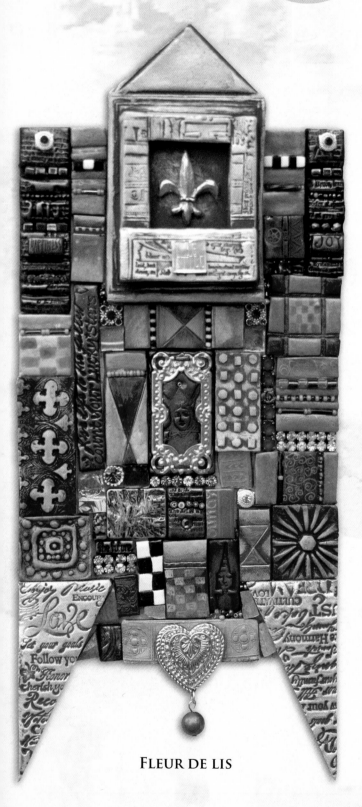

FLEUR DE LIS

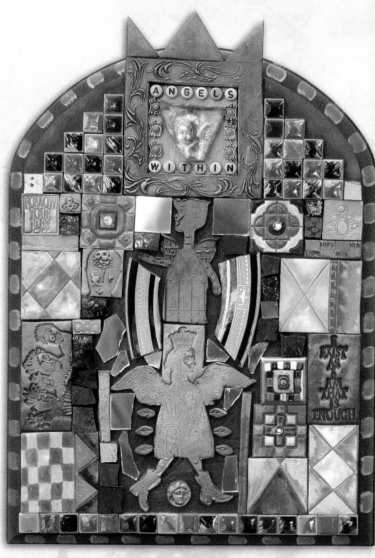

ANGELS WITHIN

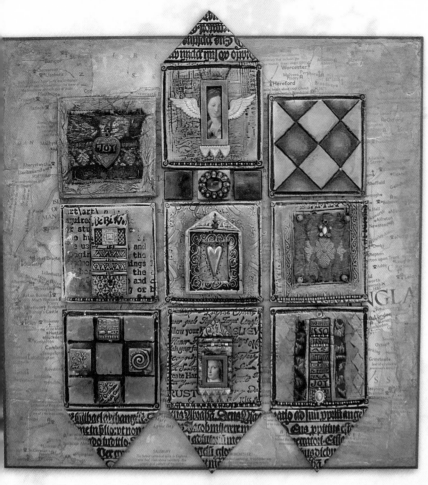

CLAY QUILT

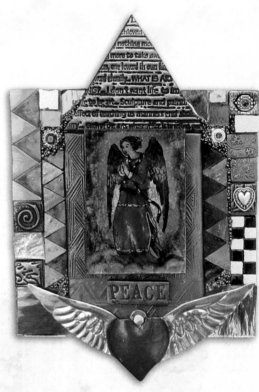

PEACE

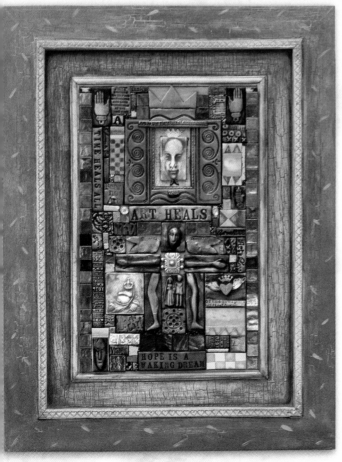

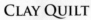

ART HEALS

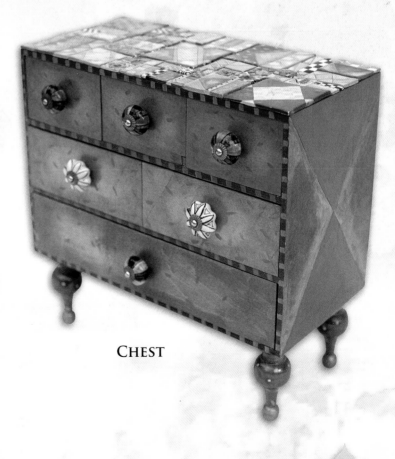

CHEST

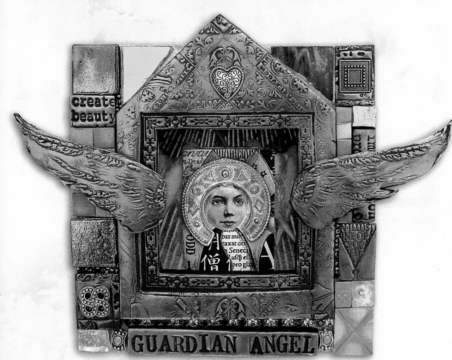

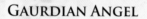

GAURDIAN ANGEL

ICON OF BEAUTY

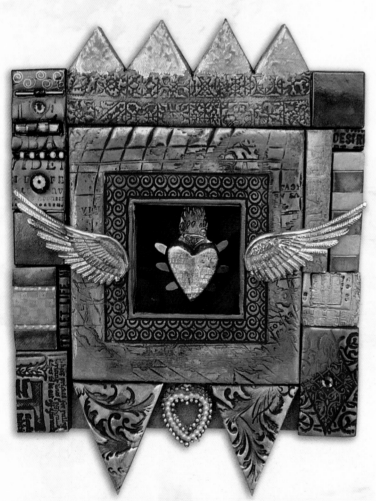

PIERCED HEART

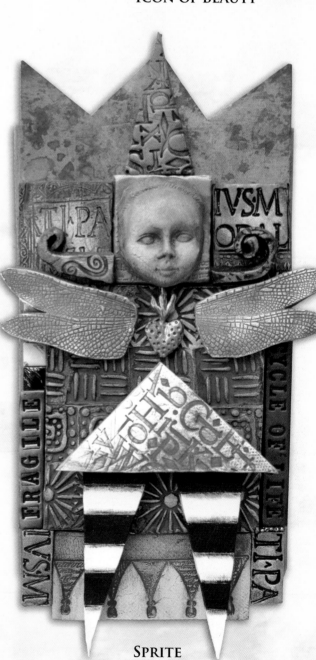

SPRITE

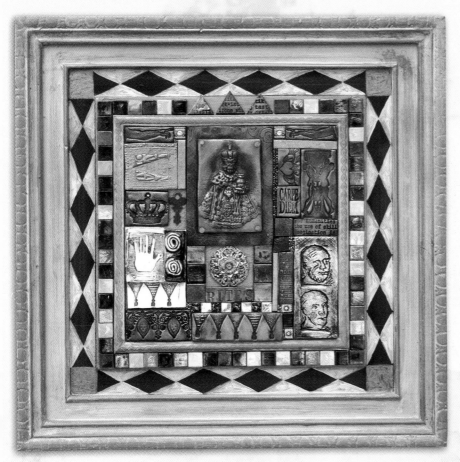

RITES OF PASSAGE

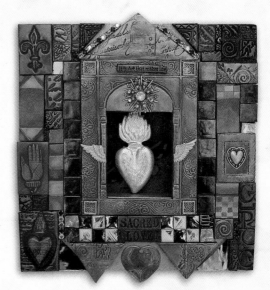

WINGED LOVE

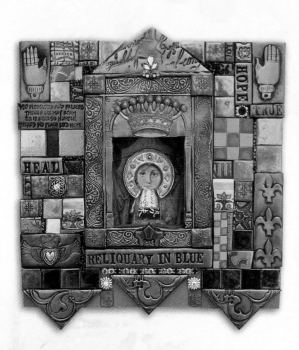

RELIQUARY IN BLUE

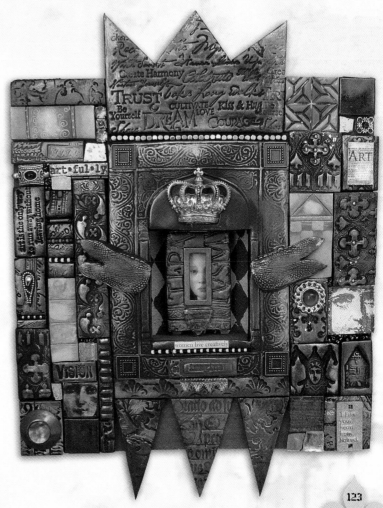

THE MUSE

RESOURCES

I buy most of my supplies online, especially the mosaic tile I use. However, I always buy Sculpey and Premo! polymer clays at the larger chain craft stores when they have their 88-cent sale! Most of the supplies I use can be found in your local craft store but, I am including the manufacturers below in case you have problems locating an item.

CLAY PRODUCTS

Amaco
800-374-1600
www.amaco.com
Rub 'n Buff

Delta Crafts
800-423-4135
www.deltacrafts.com
matte varnish

Diane Black
www.glassattic.com
resource for polymer clay questions

Duncan Enterprises
800-438-6226
www.duncancrafts.com
Scribbles dimensional paint

Golden Artist Colors, Inc.
800-959-6543
www.goldenpaints.com
paints and gel medium

Jacquard Products
800-442-0455
www.jacquardproducts.com
mica powders

JudiKins, Inc.
310-515-1115
www.judikins.com
Diamond Glaze jewelry glue

Liquitex
888-422-7954
www.liquitex.com
acrylic paints

Plaid Enterprises, Inc.
800-842-4197
www.plaidonline.com
Folk Art metallic paints

Polyform Products Company
847-427-0020
www.sculpey.com
Sculpey and Premo! polymer clays

Polymer Clay Express
www.polymerclayexpress.com
clay blades, scalpels, embossing powders

RUBBER STAMPS AND INK

Alternative Arts Productions
Fax: 253-638-6466
www.teeshamoore.com
Zettiology stamps and collage sheets

Invoke Arts
805-541-5197
www.invokearts.com
folk art rubber stamps

Gee Gee's Stamps 'n Stuff
760-729-1779
www.ggstampsnstuff.com
rubber stamps

Hampton Art
800-229-1019
www.hamptonart.com
rubber stamps

Hero Arts
800-822-4376
www.heroarts.com
rubber stamps

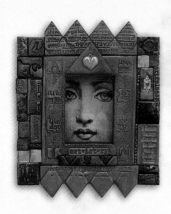

Inkadinkado
800-888-4652
www.inkadinkado.com
rubber stamps

Lost Coast Designs
408-244-2777
www.lost-coast-designs.com
rubber stamps

Postmodern Design
405-826-0289
rubber stamps

Ranger Ink
800-244-2211
www.rangerink.com
distress ink

Stamp Out Cute
559-323-7174
www.stamp-out-cute.com
letter stamps

Stampers Anonymous
800-945-3980
www.stampersanonymous.com
rubber stamps

Tsukineko, Inc.
800-769-6633
www.tsukineko.com
StazOn ink pads

Michelle Ward
Green Pepper Press
www.greenpepperpress.com
rubber stamps and inspiration

Tiles and Supplies

Happycraftn's Mosaic Supplies
608-372-3816
www.happycraftnsmosaicsupplies.com
*Van Gogh mosaic tile,
vitreous glass tile*

Monster Mosaic
888-236-4001
www.monstermosaics.com
Iridio glass tile, mirror frames

Mosaic Art Supply
404-522-7221
www.mosaicartsupply.com
porcelain tile, millefiori assortments

Mosaic Mercantile
877-966-7242
www.mosaicmercantile.com
table bases

Smalti.com
407-895-3977
www.smalti.com
smalti gold chips

Twin Hearts Mosaic
http://stores.ebay.com/
Twin-Hearts-Mosaic
irridescent glass tile, floral tile

Wits End Mosaic
888-494-8736
www.witsendmosaic.com
*gold brushed micro mosaics,
vitreous glass tile*

Ephemera

Art Chix Studio
250-478-5985
www.artchixstudio.com

Papier Valise
www.papiervalise.com

Silver Crow Creations
724-379-4850
www.silvercrowcreations.com

Studios Blackbird
877-875-5516
www.studiosblackbird.com

Miscellaneous

Custom Building Products
562-598-8808
www.custombuildingproducts.com
mastic ceramic tile adhesive

Provo Craft
800-937-7686
www.provocraft.com
shadowbox frames

Weldbond USA
800-388-2001
www.weldbondusa.com
all-purpose glue

Woodcrafter.com
800-704-3772
www.woodcrafter.com
boxes, legs, tassel beads

INDEX

ABOUT LAURIE

Laurie Mika is a mixed-media artist residing in southern California. She has painted and created art for as long as she can remember. However, her obsession with mosaics evolved over the course of the last fifteen years, culminating in a style of mixed-media mosaics that she shares in this book. Laurie holds a B.A. from United States International University, where she studied in Africa for two years. She attended graduate school at San Diego State University in the field of art history. She feels very fortunate to have combined both her love of art and her passion for travel.

Laurie has been teaching mixed-media mosaic workshops for the past few years at national retreats and truly enjoys sharing her passion for mosaics with the wonderful people she's met in classes. She has been published in numerous books and magazines and has also appeared on television on both HGTV and DIY. Closer to home, she participates in juried art shows and has work in local galleries.

With her work constantly evolving, Laurie isn't quite sure what the future holds, but she is looking forward to the journey.

Indulge your creative side with these North Light titles

Pretty Little Things
Sally Jean Alexander

Learn how to use vintage ephemera, found objects, old photographs and scavenged text to make playful pretty little things, including charms, vials, miniature shrines, reliquary boxes and much more. Sally Jean's easy and accessible soldering techniques for capturing collages within glass make for whimsical projects, and her all-around magical style make this charming book a crafter's fairytale.

ISBN-10: 1-58180-842-9
ISBN-13: 978-1-58180-842-1
paperback, 128 pages, Z0012

Collage Unleashed
Traci Bautista

Learn to collage using everything but the kitchen sink with this bright and playful book. Author Traci Bautista shows you there are no mistakes in making art. You can combine anything—from paper, fabric, paint and even paper towels to beads, metal, doodles and stitching to create unique art books, fabric journals and mixed media paintings. The book includes detailed instructions for lots of innovative techniques, such as staining/dying paper towels, freestyle hand lettering, doodling, funky embroidery and crayon transfers. Then you'll learn how to turn your newfound techniques into dazzling projects.

ISBN-10: 1-58180-845-3
ISBN-13: 978-1-58180-845-2
paperback, 128 pages, Z0024

Metal Craft Discovery Workshop
Linda and Opie O'Brien

Discover a nontraditional approach to the introduction of working with metal and you create 20 fun and funky projects. This is the whimsical side of metal that not only teaches you how to cut and join metal surfaces, but also allows you to explore ways to age and add texture to metal, conjure up beautiful patina finishes and uncover numerous types of metal such as copper, mesh, wire and recycled material. Whether you've worked with metal before or you're new to the medium, give your recyled tin cans a second glance and start crafting beautiful pieces with metal today.

ISBN-10: 1-58180-646-9
ISBN-13: 978-1-58180-646-5
paperback, 128 pages, 33235

Secrets of Rusty Things
Michael deMeng

Learn how to transform common, discarded materials into shrine-like assemblages infused with personal meaning and inspired by ancient myths and metaphors. As you follow along with author Michael deMeng, you'll see the magic in creating art using unlikely objects such as rusty doorpulls, old sardine tins and other quirky odds and ends. This book provides easy-to-follow assemblage techniques, shows you where to look for great junk and provides the inspiration for you to make your own unique pieces.

ISBN-10: 1-58180-928-X
ISBN-13: 978-1-58180-928-2
flexibind, 128 pages, Z0556

These titles and other fine North Light Books are available at your local craft retailer, bookstore or from online suppliers.